W9-BAF-772

Bags, Boxes, & Tags

ROCKPORT

Bags, Boxes, & Tags

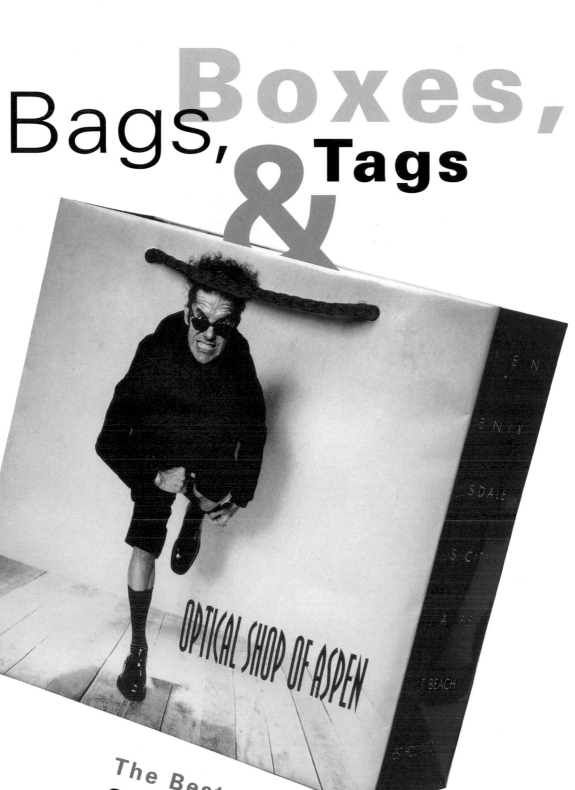

OPTICAL SHOP OF ASPEN

The Best of
Graphic Design
for Shopping Bags
& more

GLOUCESTER MASSACHUSETTS

ROCKPORT PUBLISHERS

Joyce Bautista

Copyright © 1998 by Rockport Publishers, Inc.

All rights reserved. No part of this book may be reproduced
in any form without written permission of the copyright
owners. All images in this book have been reproduced with
the knowledge and prior consent of the artists concerned
and no responsibility is accepted by producer, publisher, or
printer for any infringement of copyright or otherwise, arising
from the contents of this publication. Every effort has been
made to ensure that credits accurately comply with informa-
tion supplied.

First published in the United States of America by:
Rockport Publishers, Inc.
33 Commercial Street
Gloucester, Massachusetts 01930-5089
Telephone: (978) 282-9590
Facsimile: (978) 283-2742

Distributed to the book trade and art trade in the United
States by:
North Light Books, an imprint of
F & W Publications
1507 Dana Avenue
Cincinnati, Ohio 45207
Telephone: (800) 289-0963

Other Distribution by:
Rockport Publishers, Inc.
Gloucester, Massachusetts 01930-5089

ISBN 1-56496-557-0

10 9 8 7 6 5 4 3 2 1

Designer: Argus Visual Communication, Boston

Front cover image: Manufacturer: Keenpac North America Ltd. Project appears on page 42
Front flap images: (top) Design: After Midnight. Project appears on page 58.
 (bottom) Design: Sweiter Design U.S. Project appears on page 161.
Back cover images: (top) Design: Greenberg–Kingsley/NYC
 (center row, left to right) Design: Grafik Communications, Ltd. Project appears on page
 132; Design: Planet Design Company. Project appears on page 181; Design: Morla
 Design. Project appears on page 93; Design: After Midnight. Project appears on page 59.
Back flap images: (top) Design: Love Packaging Group. Project appears on page 166.
 (bottom) Design: Sayles Graphic Design. Project appears on page 63.

Additional Photography by Kevin Thomas Photography

Printed in Hong Kong.

Acknowledgments

I would like to thank the following: Dan Shaw for taking a chance on me. Suzanne Slesin for serving as my mentor and inspiration. Goli Maleki for all her hard work on this book and her good humor. Aaron Frank for opening my eyes to the world of design. My family for putting up with me.

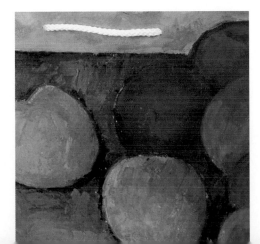

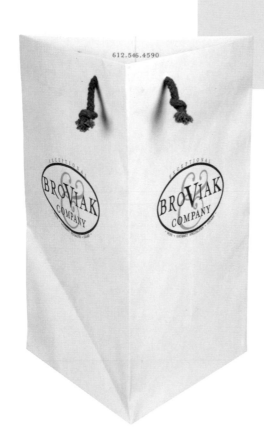

Contents

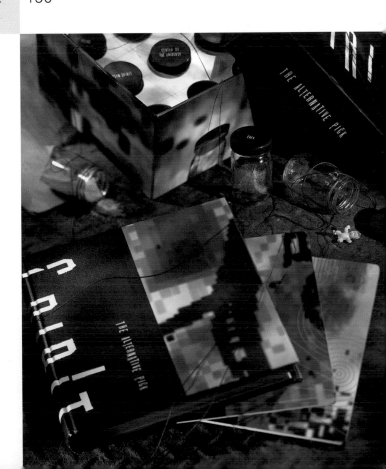

Introduction

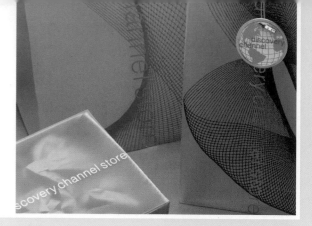

Today's shopping bags are not so far removed from their be-ribboned and be-decked elaborate cardboard cousins from haberdasheries and dressmakers of the beginning of this century. But with today's discriminating consumer buying everything and anything from the local department store to the fancy boutique on Madison Avenue, shopping bag designers must concentrate on distinguishing their concept from that of the competition—not to mention cost efficiency—but also on speaking to its customers, whether they live in Tallahassee or Tokyo. Far outliving their intended purpose, shopping bags, especially those most durable and most stylish, reappear in gym locker rooms, under office desks and at dry cleaner counters as useful carry-alls for day-to-day loads. Therefore, their design carries the weight of a company's or store's image and serves as high-profile advertising with legs. More than vessels to carry the booty of a day on Fifth Avenue, Rodeo Drive, Westbourne Grove, or Main Street, shopping bags reflect the tastes and habits of the men and women that carry them.

This book represents the democracy of information and design found in our age of Web sites and satellites. Today, we are constantly bombarded with images from all around the world. It no longer takes months for a fashion trend to work its way from the Paris runways to the small-town boutique. The dissemination of ideas is wide and almost instantaneous, as evident in the similarities of packaging design used to sell, promote, and carry consumer goods from around the world.

Some of the best bags presented herein share the same trait: simplicity. Geometric shapes add interest and bold colors add fun, but they do not overwhelm. The most effective shopping bags feature the name of the client clearly and convey the type of merchandise or service offered. Colors are limited to two and type is simple without much flourish. The quality of paper is usually a very chic matte, although a spectrum of retail clients, from high-end boutiques to small-town bakeries, are opting for natural kraft bags. This trend toward humble simplicity, at first perceived as charming, is now approaching the point of cliché. But the pendulum is sure to soon swing in the direction of over-the-top opulence; evidence of this trend can be seen in Japan—or perhaps they never abandoned it. Hopefully, a happy medium of clean, simple design with the imaginative use of color and shape will be the norm, instead of the exception.

Within the constraints of real-world business, the shopping bags collected in this book offer a mix of

clever, elegant, and fun designs that come in a variety of shapes. Not all are intended to accompany a purchase; some bags were designed as gift bags or as promotional giveaways. We found that the shopping bags and packaging have not only become much more stylish but much more varied. Shopping bags are used to hold everything from free cosmetics to bread. The variety of bags and boxes reflects our growing consumer lust for more specialty stores and services.

Like our fickle tastes for fashion, foods, music, etc., our demands for visual stimulation change often. Some designs will endure with little modification—the Tiffany blue, the Cartier script on red—forever etched on the consumer psyche. Today, designers hope to make the same impact by updating the packaging of old products and by shaping the image of new products that harken back to the graceful lines from the turn-of-the-century and to the clean, bold text and images of the post-war consumer boom of the 1950s and 1960s adding further proof to the adage: "Everything old is new again."

Joyce Bautista

Textiles, Art, & Specialty

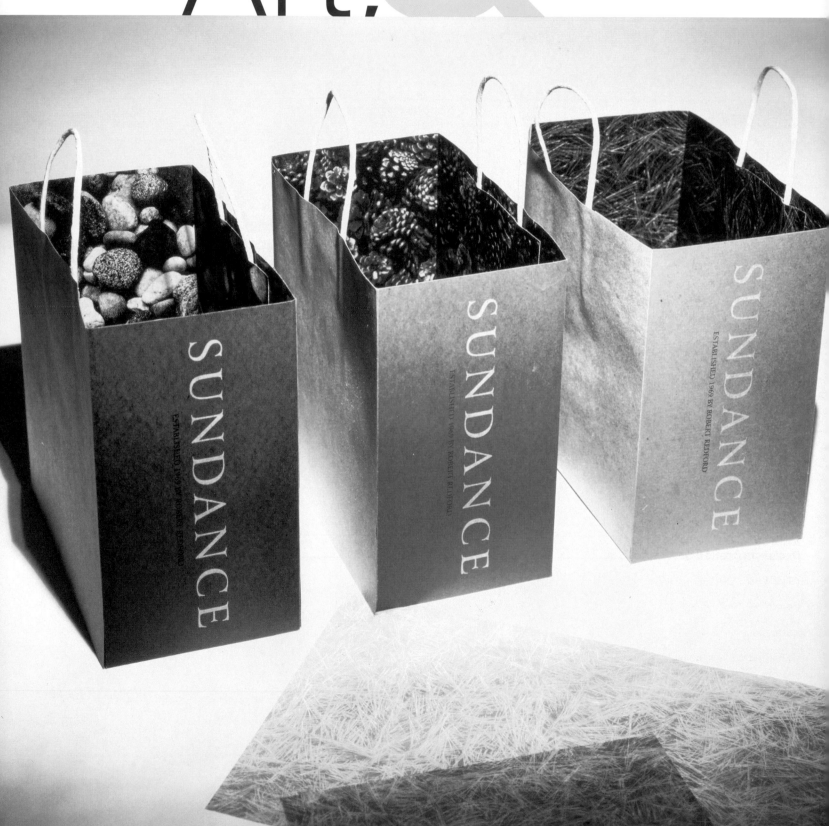

Given to designers at trade shows and public relations events, the bag features
a wallcovering and border design from the company's collection.

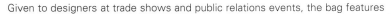

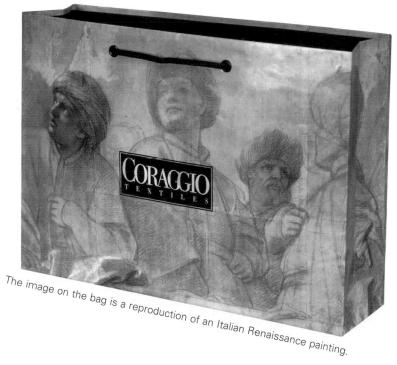

Client
Blonder Wallcoverings/
Cambridge Studios
Designer
Carl Girbino
Manufacturer
S. Posner Sons Inc.

Client Coraggio Textiles
Design Firm Gervin Design
Manufacturer New Weave Corporation
Paper/Printing 150 gsm paper;
four-color process; gloss film lamination

Client Dayton Hudson
Corporation
Design Firm design guys
Art Director Steven Sikora
Designers Richard Boynton
and Steven Sikora
Distributor Marshall
Field's/Sundance
Paper/Printing Printed
two-color, two sides on
kraft paper

The Sundance Shop Bags, used
with pine needle tissue paper,
reflect the craftsmanship and
character of the ecologically
friendly products. Imprints of
three natural elements are inside
the bags and also appear in other
places throughout the store.

The image on the bag is a reproduction of an Italian Renaissance painting.

Client State & Company Jewelers
Designer Heather B. Smith
Distributor Image Packaging
Manufacturer Keenpac North America Limited

The sheen of the lettering is fitting for the jewelry store theme. The reason behind the triangular shape of the bag is a bit of a mystery, which perhaps relates to the question mark in the logo.

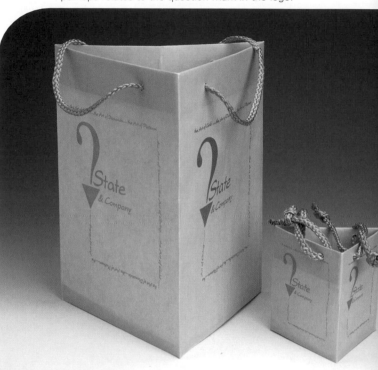

Client
AnnieGlass
Design Firm
Russell Leong Design
Art Director/Designer
Russell Leong
Manufacturer
Conifer/Crent Company

The AnnieGlass bag displays the corporate logo in a green that is reminiscent of the green slump glass in many of their products.

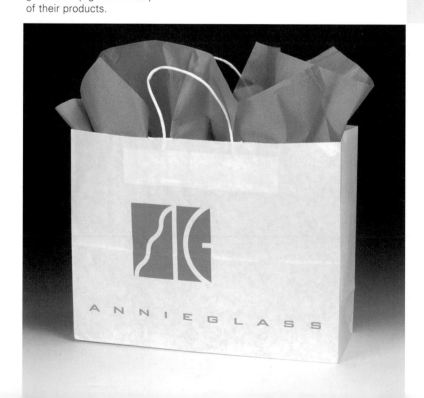

Client Apartment 48
Design Firm John Campagna Design
Designer John Campagna

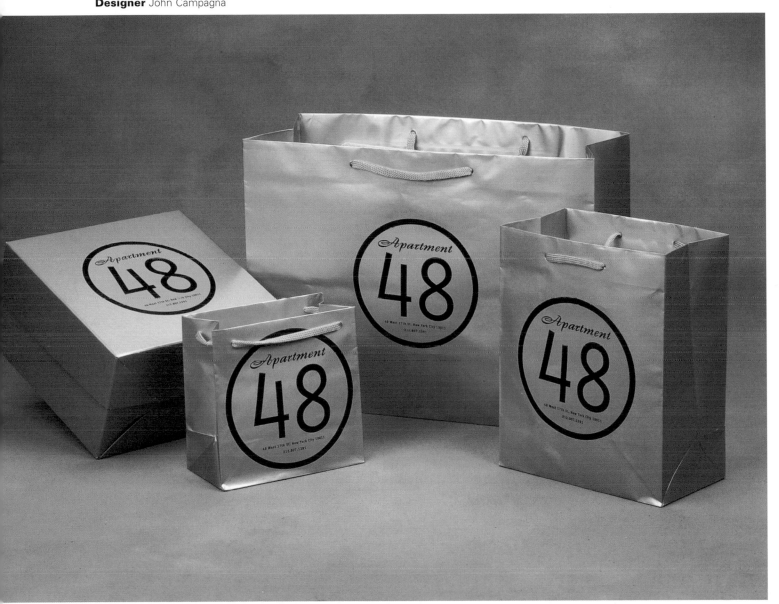

The goal was to create a logo that combined two seemingly disparate elements: an elegant script and the functionality of the street address.

Client Uncle Dan's
Distributor Greenebaum Brothers
Manufacturer Bonita Pioneer
Paper/Printing Four-color ink printing
on natural kraft paper and box; four-
color printing on low-density film
plastic; one-color IMS flexoprinting

The Chicago outdoor and camping supply store required packaging
for a variety of products with a broad range of sizes and weights.

Client
Antkoviak Custom Furniture
Design Firm Antkoviak
Art Director Jeff Brown
Designer Fernando Cortazar
Manufacturer Duro Bag
Manufacturing Company

The playful script accents the undulating line below that presents the store's vital statistics.

Client Tabacos Gran Columbia
Design Firm Greteman Group
Art Director Sonia Greteman
Designers Sonia Greteman
and James Strange
Paper/Printing Litho Label

Inspired by South American packaging from the 1920s and 1930s, the design features a modern twist—a powerful woman is pictured in front of fields that are ripe for harvest.

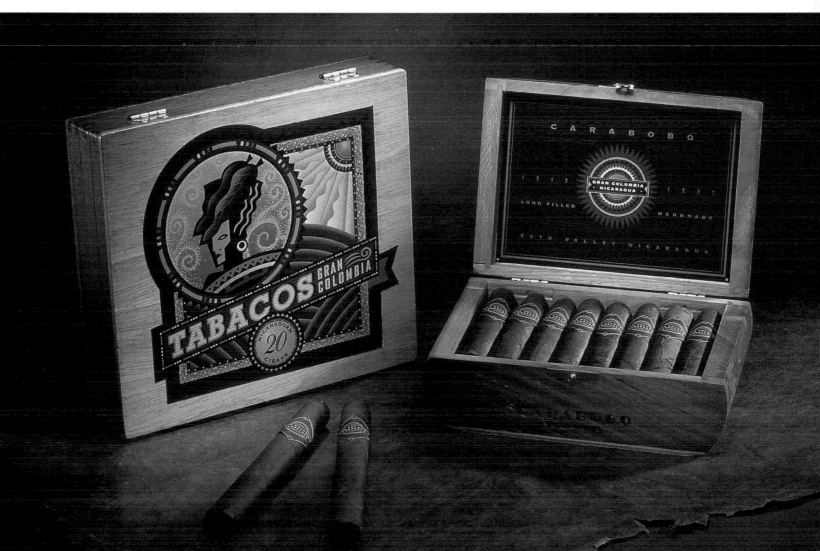

Client Taylor Guitars
Design Firm Mires Design
Art Director Scott Mires
Designers Miguel Perez and Scott Mires

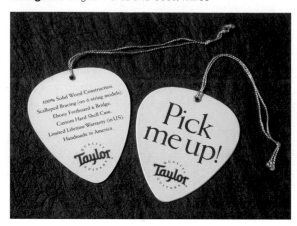

The designers found that the shape of a guitar pick could easily be used as a hangtag. This gave the tags a creative look and helped potential buyers differentiate Taylor guitars' special features from those of other guitars.

Client Radio Rerun/The Original Baby Tucky
Design Firm Jim Lange Design
Distributor The Marketing Group
Manufacturer The Marketing Group
Paper White-coated 100-lb cover
Printing Accord Carton

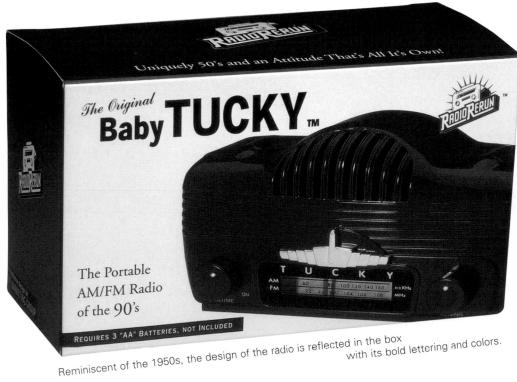

Reminiscent of the 1950s, the design of the radio is reflected in the box with its bold lettering and colors.

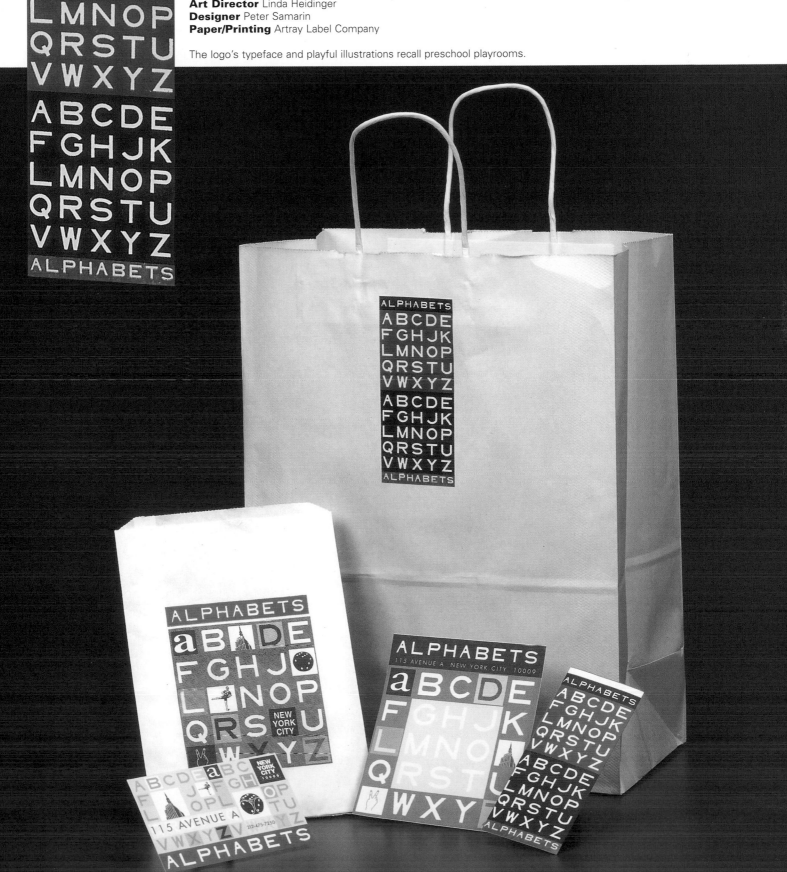

Client Alphabets
Design Firm Alphabets In-house
Art Director Linda Heidinger
Designer Peter Samarin
Paper/Printing Artray Label Company

The logo's typeface and playful illustrations recall preschool playrooms.

Fashion, & Cosmetics
Fragrance,

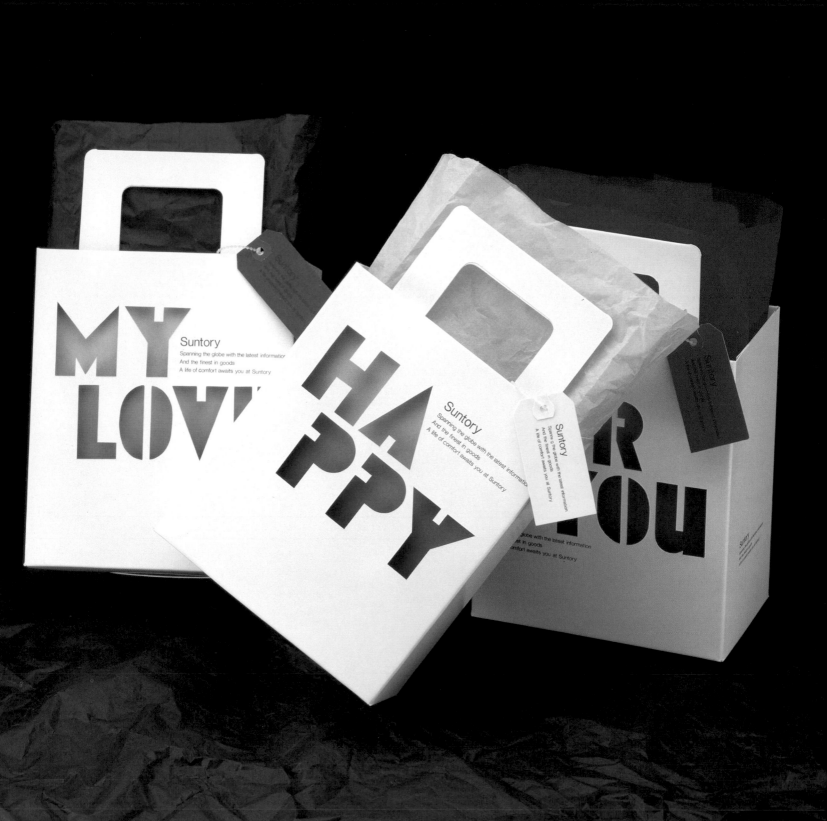

The paper airplane graphic coupled with the stylized man on the run conveys the store's attitude as catering to men who are well traveled and sophisticated. In fact, *carnet* is French for an airplane's log.

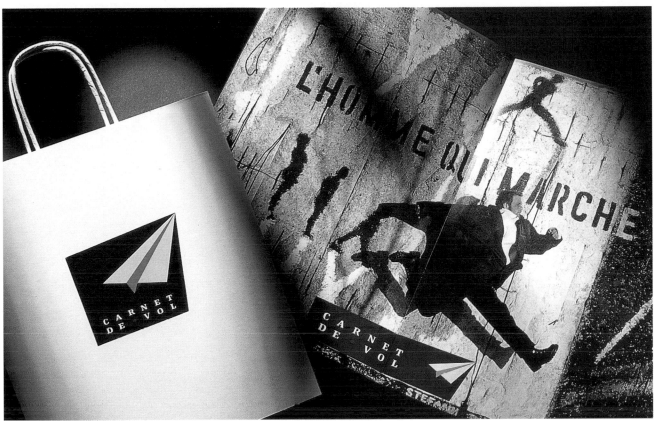

Client Carnet de Vol
Design Firm Carré Noir
Art Director/Designer
Jean-Christophe Cribelier
Manufacturer Lambacel
Paper/Printing Varnished
brown kraft; weights from
110g to 120g

Client Suntory Co., Ltd.
Design Firm Package Land Co. Ltd.
Art Director/Designer Yasuo Tanaka

With their personal die-cut phrases, unique shape, and bright
hues, the bags are ideal for the presentation of gifts.

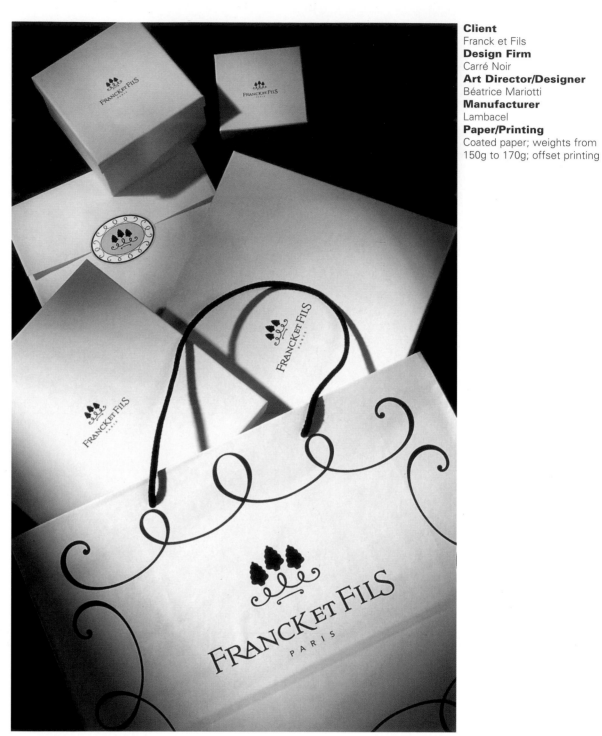

Client
Franck et Fils
Design Firm
Carré Noir
Art Director/Designer
Béatrice Mariotti
Manufacturer
Lambacel
Paper/Printing
Coated paper; weights from
150g to 170g; offset printing

The logotype and the graphic universe reflect the refinement
and culture of the sophisticated company.

Here, shimmery bath salts wrapped in a parchment pouch printed with a graceful mermaid bathing in the sea and tied closed with a ribbon. For the line of perfumed soaps, the designer hand-rendered a monogram logo and chose an elegant purple and gold color palette where three levels of embossed gold ink were utilized.

Client Gianna Rose/Sels des Marées
Design Firm Sayles Graphic Design
Art Director/Designer/Illustrator John Sayles

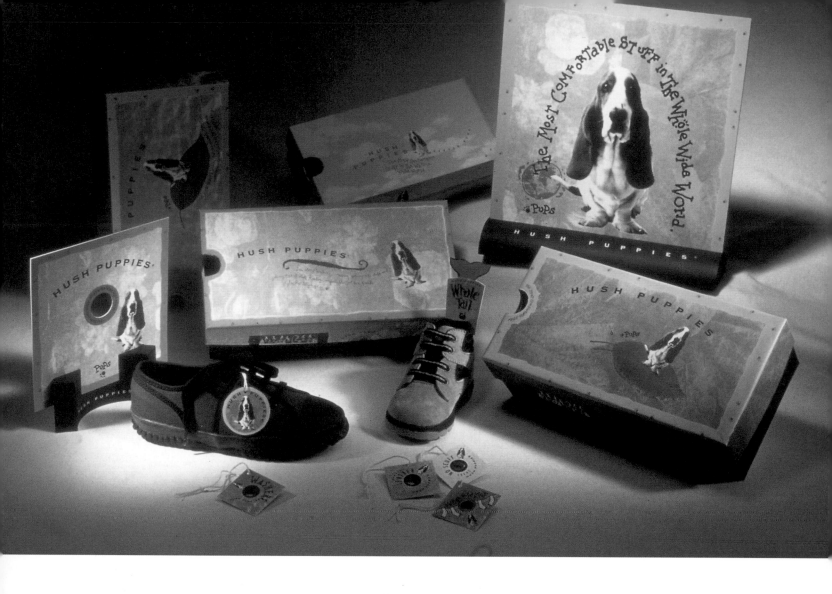

The packaging for Hush Puppies Kids shoes created three distinct categories: Boys, Girls, and Infants and Toddlers. Colors and textures were chosen to appeal to each group, yet are still visually linked to Hush Puppies adults' shoe packaging. The inside tops encourage children to find alternate uses for the shoe boxes.

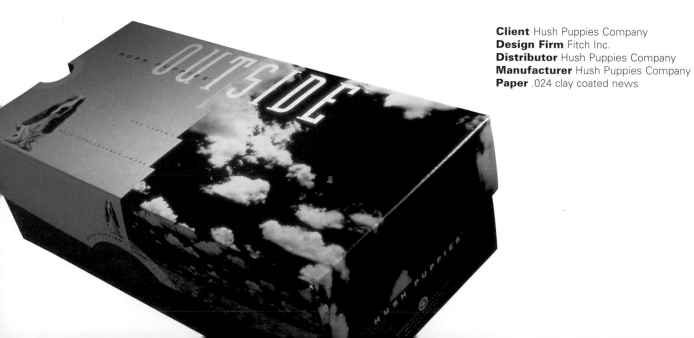

Client Hush Puppies Company
Design Firm Fitch Inc.
Distributor Hush Puppies Company
Manufacturer Hush Puppies Company
Paper .024 clay coated news

The grid of images effectively tells the story of La Prairie's attention to organic elements in its beauty products. The laminated paper and finely reproduced photographs make for a very sleek and coveted bag.

Client
La Prairie
Art Director
Ched Vackorich
Manufacturer
S. Posner Sons Inc.

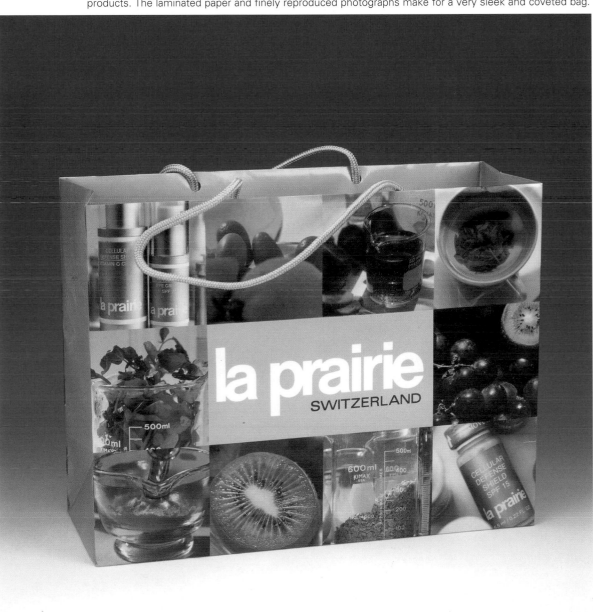

The Tommy Hilfiger identity can be found in many places and is as common on the sides of buses as it is on people's backs. This bag for the flagship store is also printed with stripes on the inside.

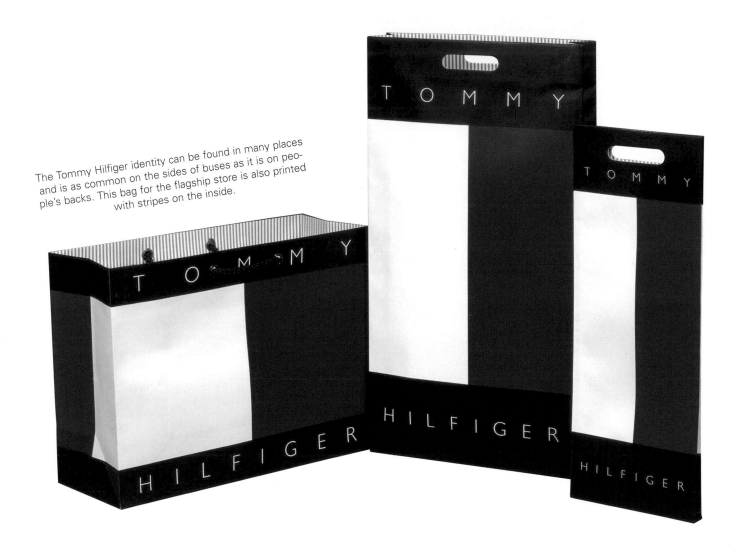

Client Tommy Hilfiger Flagship
Distributor Image Packaging
Manufacturer Keenpac North America Limited

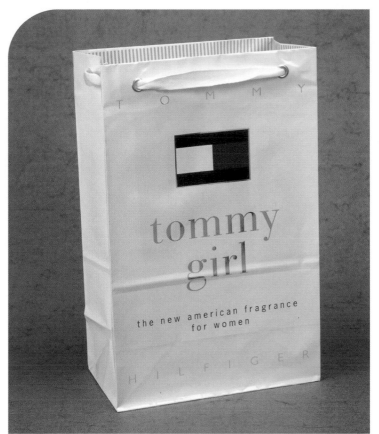

Client
Tommy Girl/Estée Lauder
Design Firm
Aramis In-house
Manufacturer
Modern Arts Packaging

Designed for in-store promotions, the bag features the familiar Tommy Hilfiger logo and a unique handle that is threaded through each of its four sides.

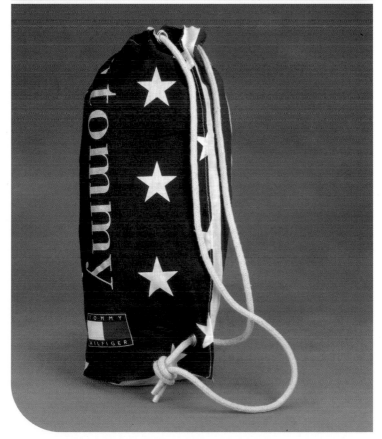

Client
Tommy Hilfiger/Estée Lauder
Design Firm
Aramis In-house
Manufacturer
Modern Arts Packaging

The giveaway cotton bag with the familiar logo unites the fashion and fragrance products of Tommy Hilfiger.

Client Firenze/Matsushiro Co., Ltd.
Design Firm Package Land Co. Ltd.
Art Director/Designer Yasuo Tanaka

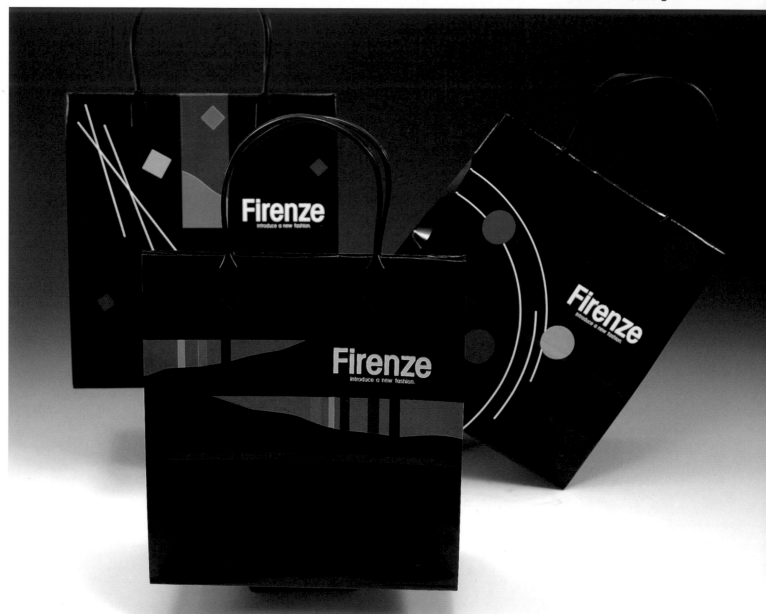

The bright colors against the plain black
background compel the viewer to investigate
where this bag might have come from.

The Japanese clothing company's bags exhibit a bright, abstract geometric design.

Client
Daishin Co. Ltd.
Design Firm
Package Land Co. Ltd.
Art Director/Designer
Yasuo Tanaka
Manufacturer
Toyoh Shigyo Co., Ltd.

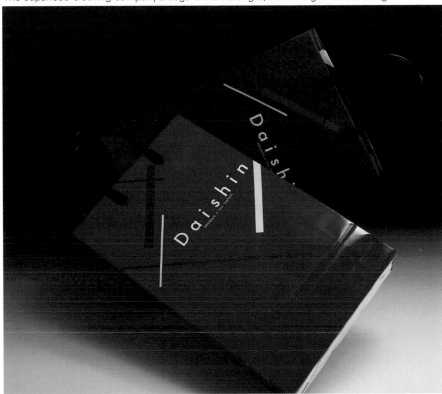

Client
May Co.
Design Firm
Private Label
Art Director
Sarah McDonald
Manufacturer
Keenpac North
America Limited

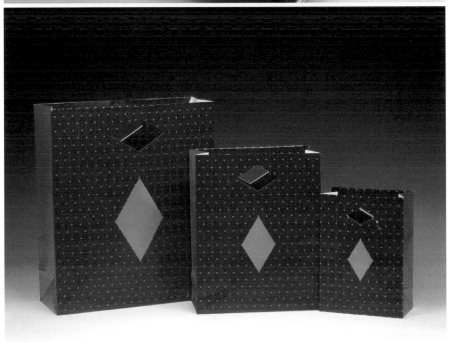

Effective as beautiful giftwrap but not as practical advertising for the store,
the pattern is appropriately named Harlequin.

Client Elizabeth Ryan
Distributor Gift Box Corporation of America
Manufacturer Keenpac North America Limited

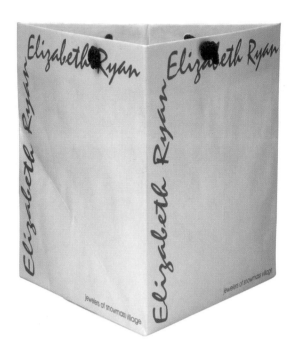

Client Ruth Young
Distributor
Commonwealth Packaging
Manufacturer Keenpac North
America Limited

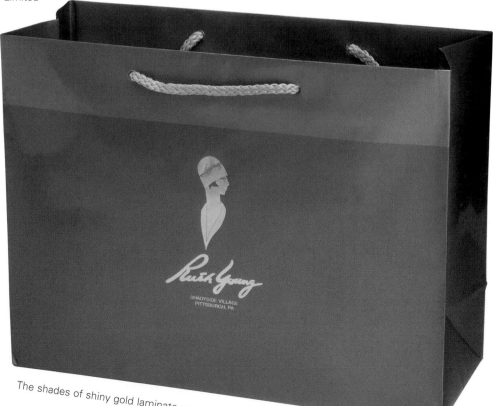

The shades of shiny gold laminate coupled with the elegant Art Nouveau logo make a lovely and understated bag.

The sentence "This design is well-balanced, well-formed and great"
exhibits the Japanese interest in including phrases in their packaging.

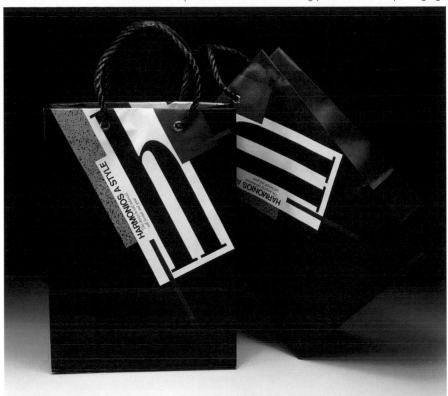

Client
Harmonios A Style/
Matsushiro Co., Ltd.
Design Firm
Package Land Co. Ltd.
Art Director/Designer
Yasuo Tanaka

Client La Seine/
Matsushiro Co., Ltd.
Design Firm Package
Land Co. Ltd.
Art Director/Designer
Yasuo Tanaka

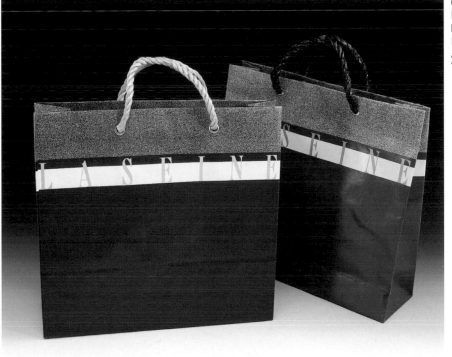

The braided rope handles, grommets, and textured design
blend to suggest a sense of sturdy quality.

Client
Columbia Sportswear
Designer
Borders, Perrin and Norrander
Distributor
Zellerbach
Manufacturer
Bonita Pioneer Packaging

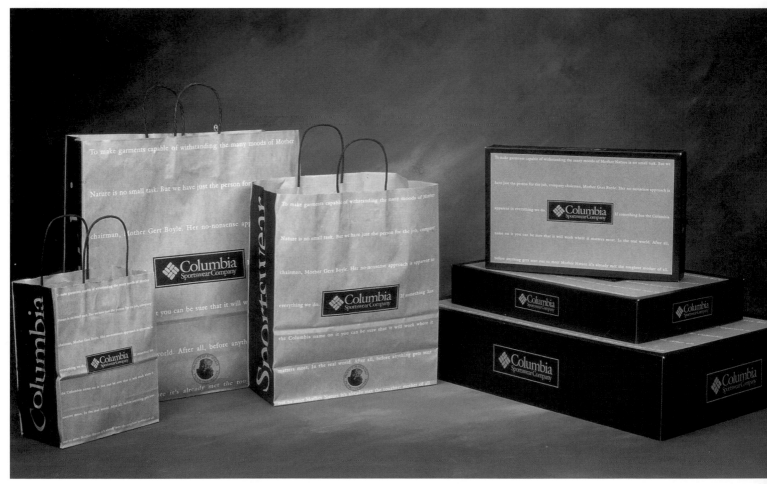

The natural kraft paper and simple printing encourage an emphasis on the clothing rather than the packaging.

Client Mayer-Berkshire Legwear
Design Firm Mayer-Berkshire Corp.
Art Director/Designer Jennifer Stanley
Manufacturer Modern Arts Packaging

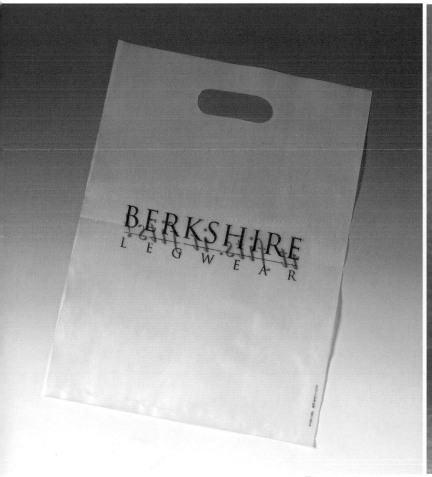

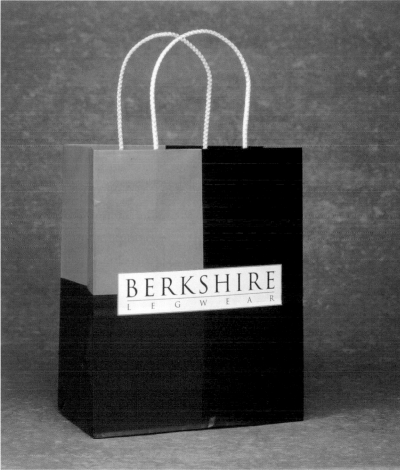

The two-piece promotion consists of a gloss-laminated shopping bag and a high-density sample bag.

The inspiration for the shape of the bag came from the structure of old apple-picking satchels. The bag has pinched gussets, which give it a more streamlined appearance than the more common inward-folding ones achieve.

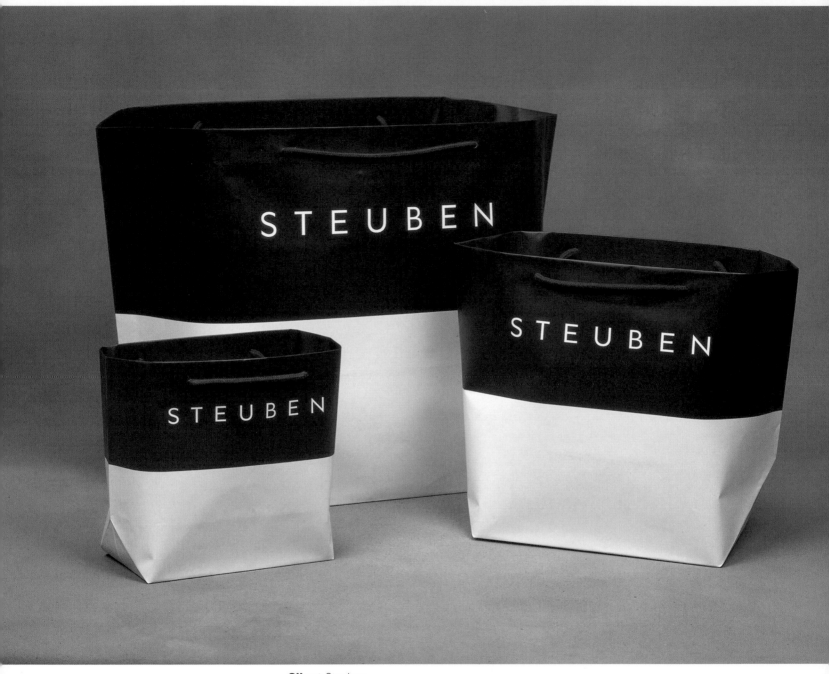

Client Steuben
Design Firm Matsumoto Incorporated
Designers Takaaki Matsumoto and Tina Gianesini
Distributor Image Packaging
Manufacturer Keenpac North America Limited

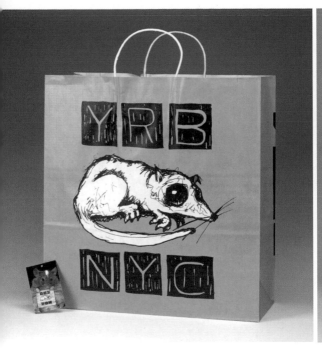

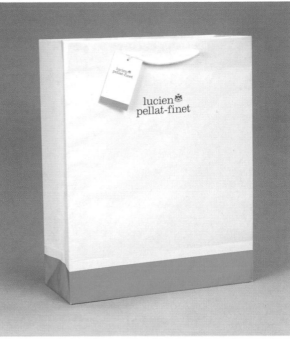

Client
Lucien Pellat-Finet
Design Firm
Rick Rogers Design, Inc.
Art Director
Rick Rogers
Distributor
The Metro Packaging
Group, Inc.
Manufacturer
Ginger Graphics (tag);
Pacobond (bag)
Paper/Printing
Bleach white tag stock/two-
color offset (tag); bleach
white offset kraft/two-color
offset (bag)

Client Yellow Rat Bastard
Designer David Abergel, Y.R.B.

The rough-hewn lettering
and rat graphic capture the
young, devil-may-care attrib-
utes of the streetwear craze
in youth and mainstream
American culture. The YRB
acronym discreetly an-
nounces the name of the
store to hipsters in the know

Designed for an upscale European designer of cashmere
clothing, Lucien Pellat-Finet's minimalist, clean logo, set
against a bleach-white background, bespeaks refinement
and classic elegance.

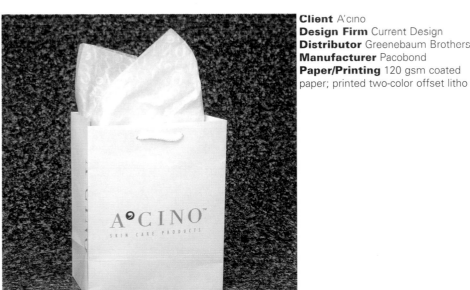

Client A'cino
Design Firm Current Design
Distributor Greenebaum Brothers
Manufacturer Pacobond
Paper/Printing 120 gsm coated
paper; printed two-color offset litho

In addition to the usual appearance on the front, the sleek
logo is printed on the side of the bag and can also be found
in subtle form on the tissue paper.

Heavy, leather-like paper stock serves as a sophisticated background to simple gold lettering.

The bag is designed for the launch of the fragrance product in department stores.

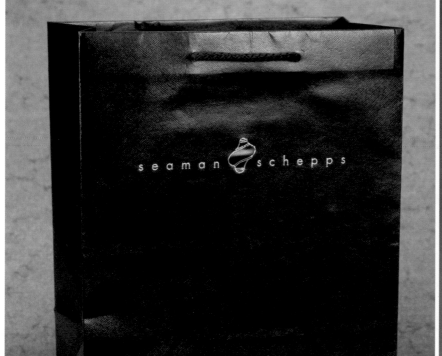

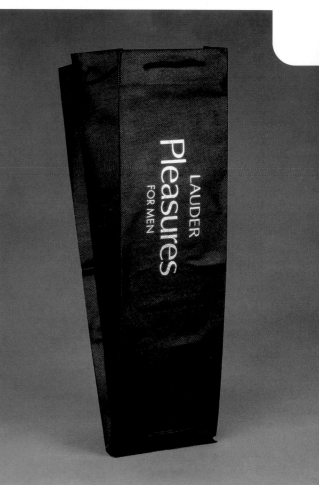

Client Seaman Schepps
Manufacturer El Pak
Paper/Printing Skivavtex 170 gsm; gold-stamped and embossed

Client Lauder Pleasures for Men/Estée Lauder
Design Firm Estée Lauder In-house
Manufacturer Modern Arts Packaging
Paper/Printing Non-woven polypropylene "E" bag

Intended for promotional distribution of product and informational materials, the bag's design is as fresh and clean as the item it advertises.

Created for a retailer of custom footwear, the design, logo, and colors are part of a new comprehensive identity program implemented by the design firm. The tissue paper provides a touch of whimsy and 1960s Pop Art.

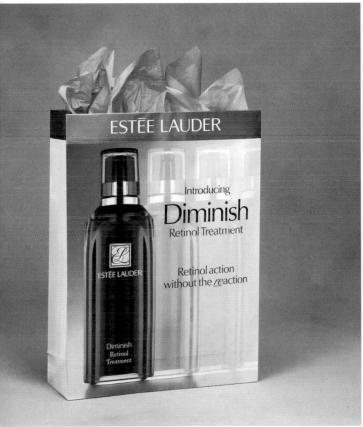

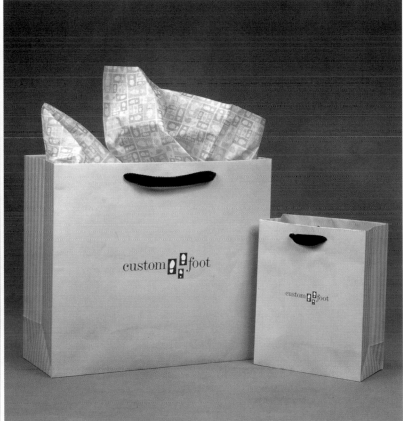

Client Diminish/Estée Lauder
Design Firm Estée Lauder In-house
Manufacturer Modern Arts Packaging

Client Custom Foot
Design Firm Alexander Isley Inc.
Art Director Alexander Isley
Designer Collen Sion
Manufacturer 2T Packaging Inc.
Paper/Printing Three-color process

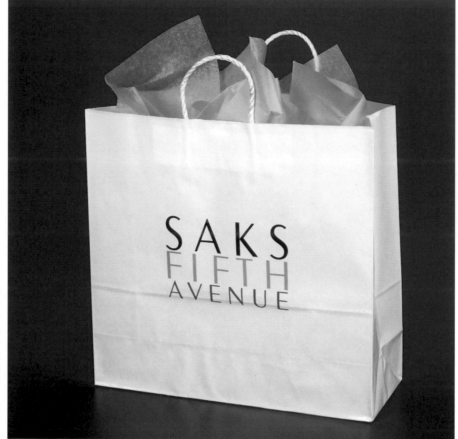

Client
Saks Fifth Avenue Everyday
Distributor
Duro Bag Manufacturing
Company
Paper/Printing
UV coating with a white
three-ply handle

The unpretentious, elegant
bag is evocative of other
high-end department stores.

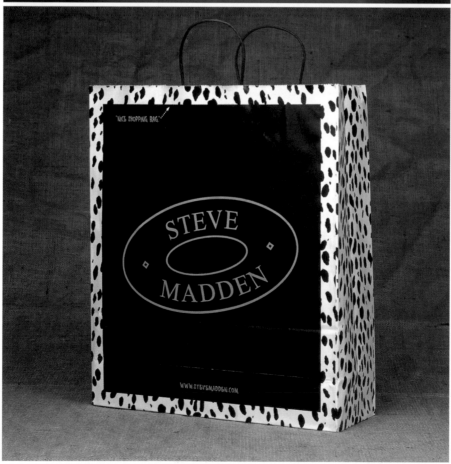

Client
Steve Madden
Design Firm
Hampel Stefanides
Art Director/
Designer/Illustrator
Tom Kane
Distributor
Kingsway Paper Company
Manufacturer
Interstate Packaging Corporation
Paper/Printing
Claycote substrate/flexographic
printing; two-color line art pro-
duced at 100-line screen using
water-based inks

The black-and-white animal print
on the front, back, and side panels
of the bag hints at the wild and
youthful character of this fashion
footwear chain.

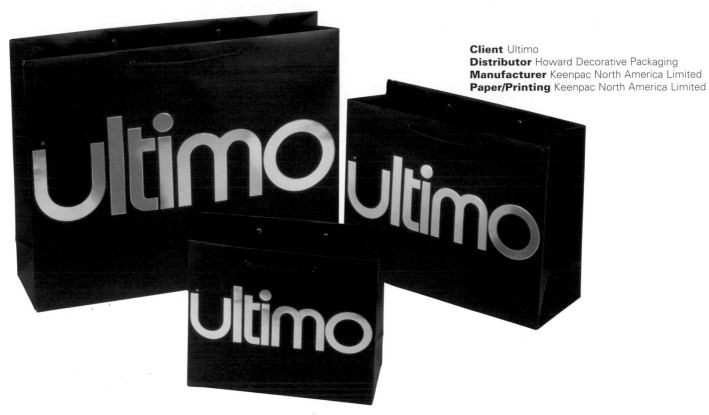

Client Ultimo
Distributor Howard Decorative Packaging
Manufacturer Keenpac North America Limited
Paper/Printing Keenpac North America Limited

The shiny silver logo on the matte black bag makes a classy, bold statement.

Client Victoria's Secret
Design Firm Desgrippes Gobé & Associates
Creative Director Phyllis Aragaki

The hosiery packaging for this celebrated lingerie brand suggests objects that are familiar to the intimate, romantic world of Victoria's Secret, such as a love letter and a hatbox.

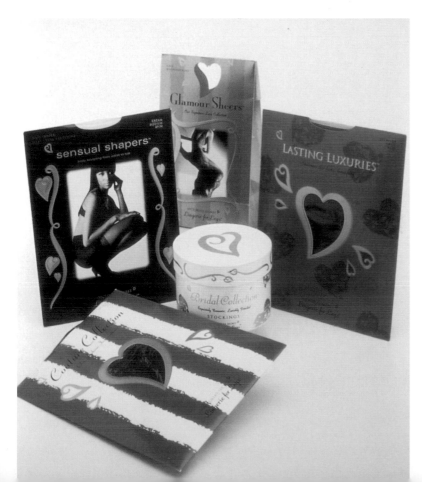

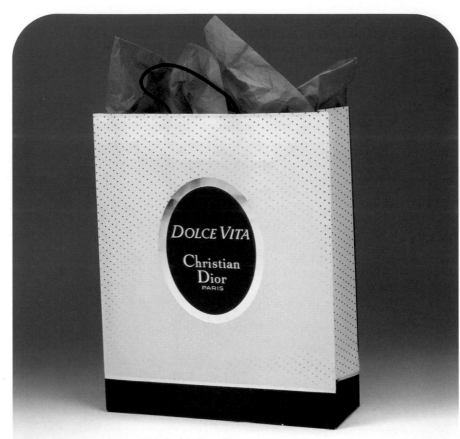

Client
Dolce Vita/Christian Dior
Perfumes
Designer
Dominique Garnier
Manufacturer
S. Posner Sons Inc.

Designed to capture the
essence of the fragrance
and the bottle, the combina-
tion of yellow and black is a
striking statement.

Client Pastec
Designer Sara Spinelli

These bags are unique and hand-
sewn using handmade paper
from China and India. Their look
is updated frequently.

Client Veranda
Manufacturer Keenpac North America Limited

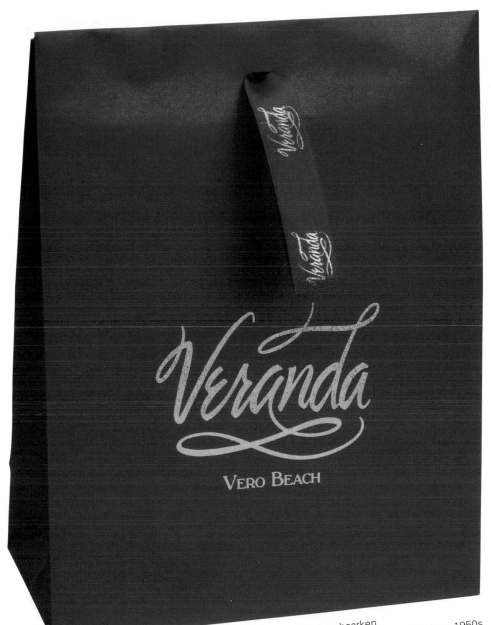

The bright pink bag, ribbon, and feminine script of this bag hearken back to the glamorous, fabulous 1950s.

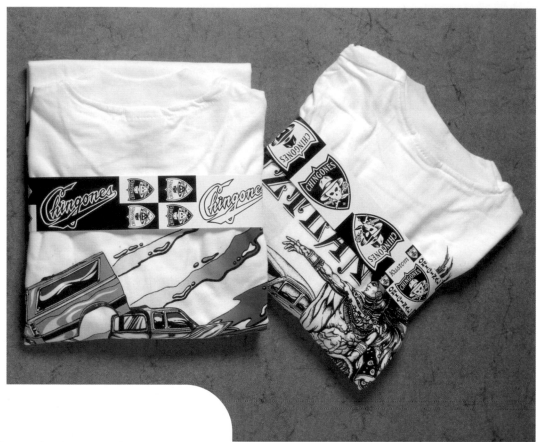

The merchandising items function as labels or hangtags and as wraparound bands to package folded T-shirts. The skull logo evokes the tough image of the streetwear industry.

Client
Chingones
Design Firm
Mires Design
Art Director/Designer
Jose A. Serrano
Illustrator
Tracy Sabin
Paper/Printing
Kromekote/Continental Graphics

The updated look consists of a modest logo that merely presents the name in a subtle gray on the neutral background.

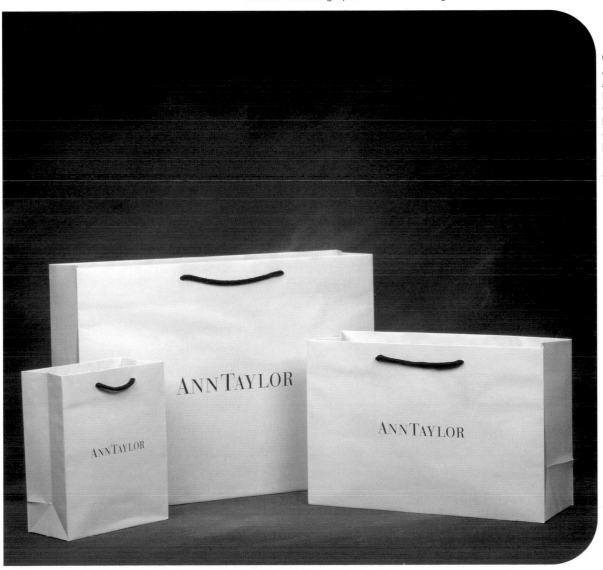

Client
Ann Taylor
Art Directors/Designers
Daniel Stark and Gaemer Guiterrez
Distributor
Creative Retail Packaging
Manufacturer
Keenpac North America Limited

Client
Optical Shop of Aspen
Distributor
Design Packaging
Manufacturer
Keenpac North America Limited

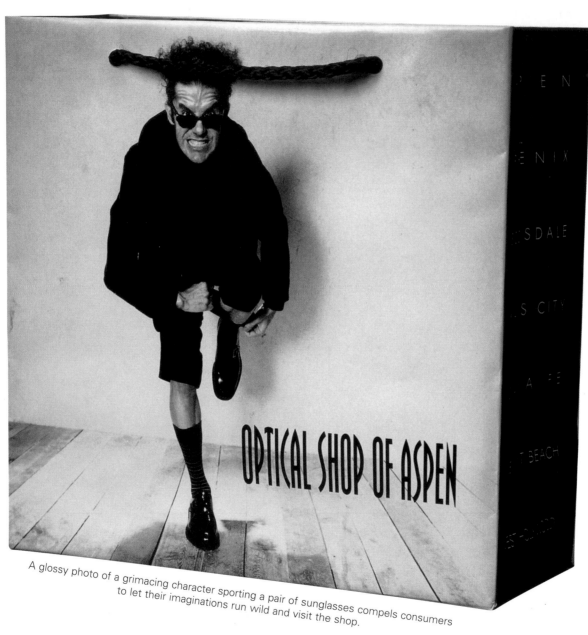

A glossy photo of a grimacing character sporting a pair of sunglasses compels consumers to let their imaginations run wild and visit the shop.

Bags, Boxes, & Tags

By utilizing a one-color printing process, the costs of producing the striking bag were kept down.

Client
Merle Norman Cosmetics
Distributor
Howard Decorative
Manufacturer
Bonita Pioneer Packaging

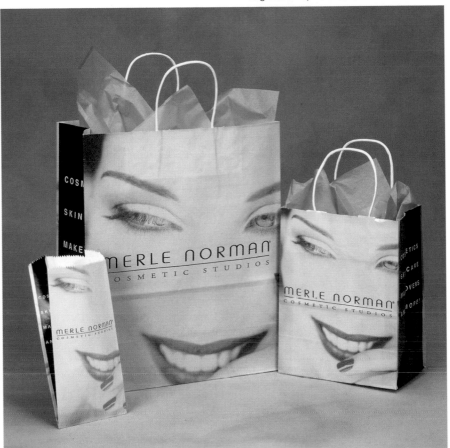

Client
Vivienne Tam
Design Firm
Vivienne Tam
Designer
Vivienne Tam
Manufacturer
Elite Co. Ltd.
Paper/Printing
Natural kraft

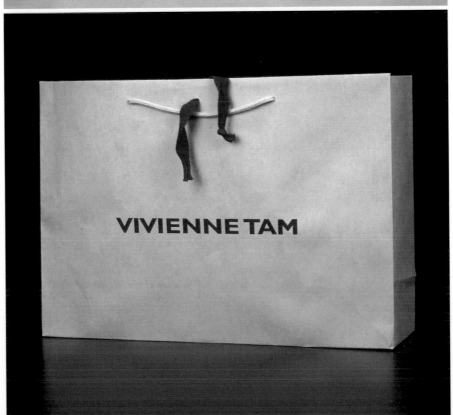

Distributed to customers of its New York City and Japan boutiques, the design is unadorned yet exudes a unique, Asian feel with a simple red ribbon tie.

Client
Aspen Traders
Design Firm
Gardner Design
Art Director
Bill Gardner
Designer
James Strange

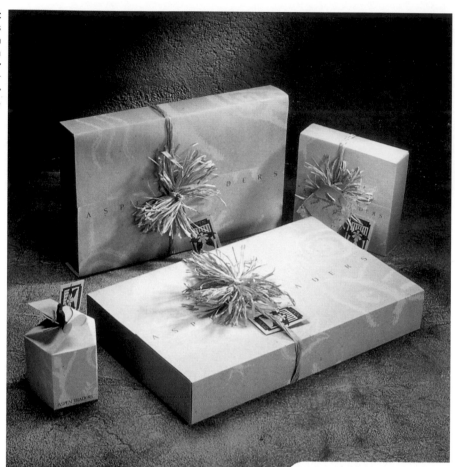

Mirroring the style of the clothing and gifts sold by the store, the packaging and raffia ribbon are all-natural.

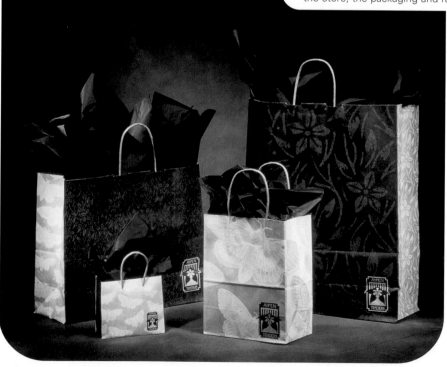

Client Orcanta
Design Firm Carré Noir
Art Director/Designer Aurore Trabuc
Manufacturer Lambacel
Paper/Printing Varnished 110g white kraft

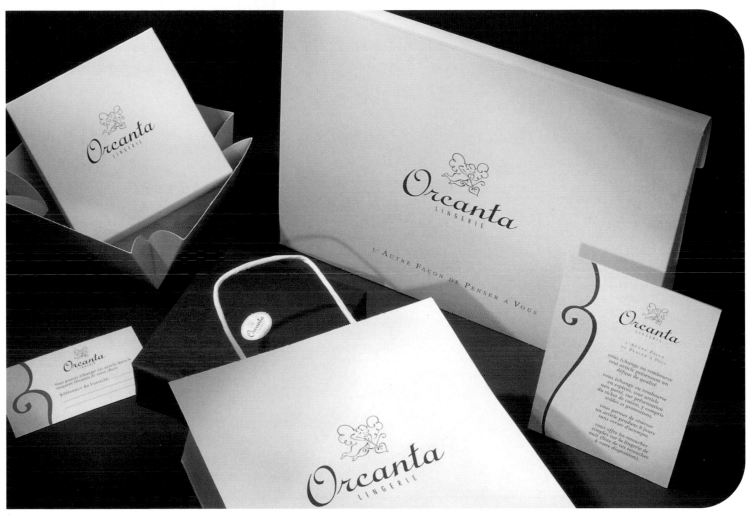

The flowing script of the logo and undulating line on the cards recall the curves of embroidered lace that one might find at the lingerie store.
The soft shades of purple hint at the obviously female clientele, and the mischievous angel suggests the potential naughtiness the store can inspire.

Client Le Bon Marché Rive Gauche
Design Firm Carré Noir
Art Director/Designer Béatrice Mariotti
Manufacturer Lambacel
Paper/Printing Varnished white kraft; weights
from 110g to 140g

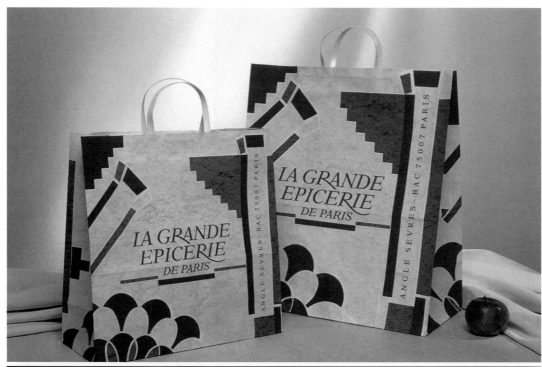

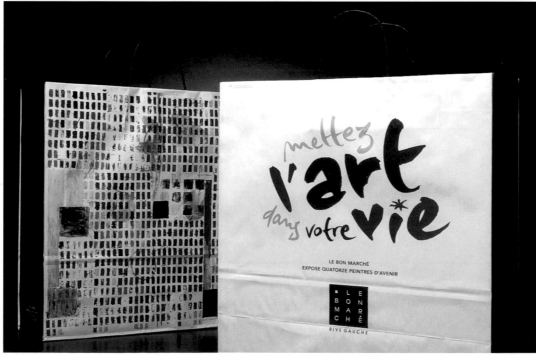

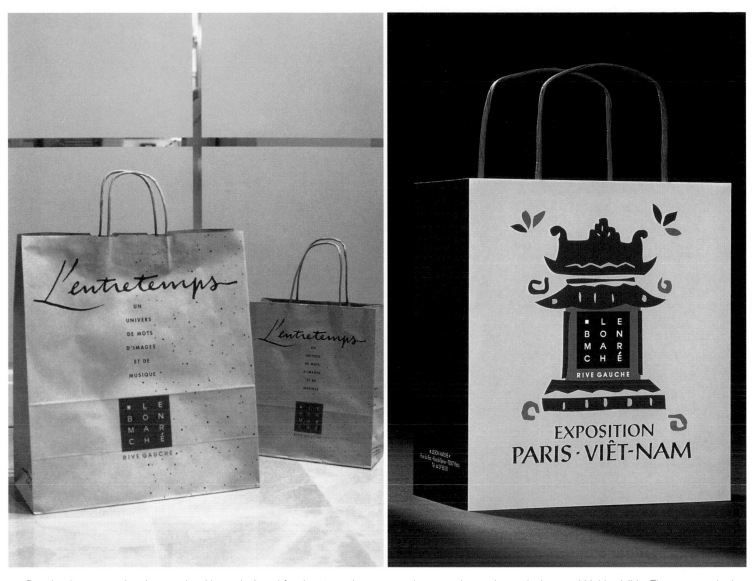

Despite the seasonal and promotional bags designed for the store, the company logo remains unchanged, clear, and highly visible. The two standard shopping bags feature bright colors and bold designs constructed around the store's name, which is printed in black-and-white; the design is "sophisticated but youthful." The bag utilized for the exhibition "Paris-Vietnam" obviously nods to Far East influences with the use of the pagoda shape and the color red.

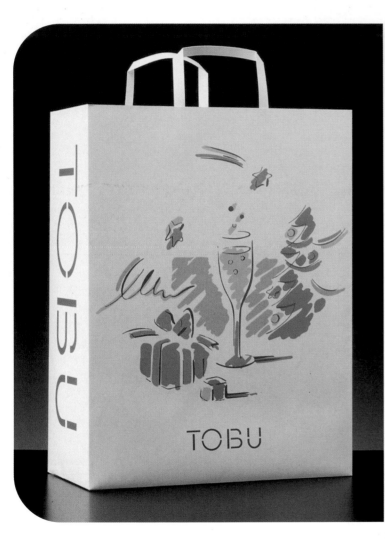
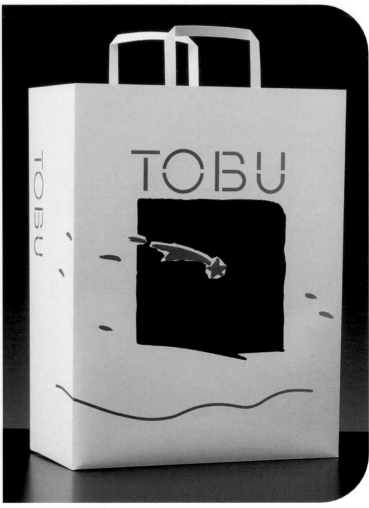

Client Tobu
Design Firm Carré Noir
Art Director/Designer/Illustrator Piotr

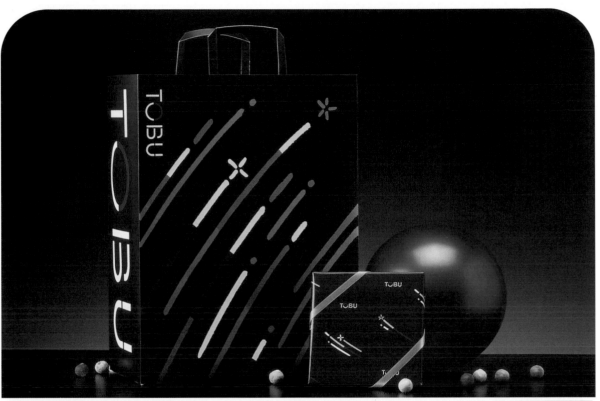

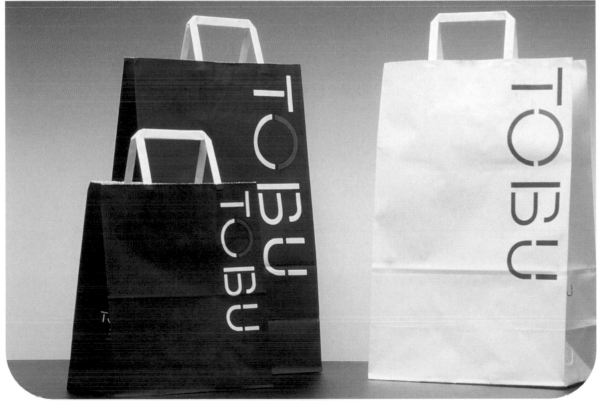

The bags for a Japanese department store possess a Western tone; the lines cutting across the paper's surface are suggestive of a design style that was popular in the United States in the 1980s.

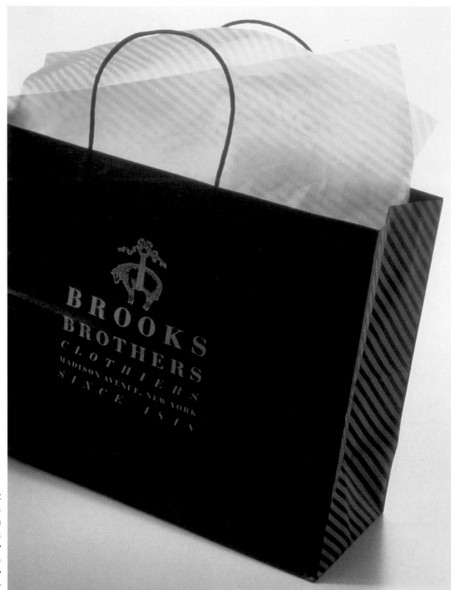

Client
Brooks Brothers
Design Firm
Desgrippes Gobé & Associates
Art Director
Christopher Vice
Designer
Nick Livesy

To revitalize the classic men's apparel brand, the designer did away with fussy script and added graphic diagonal lines on the side panels. However, with the inclusion of the "Golden Fleece" icon, "clothiers," and "since 1818," the simplified logo still evokes its grand tradition.

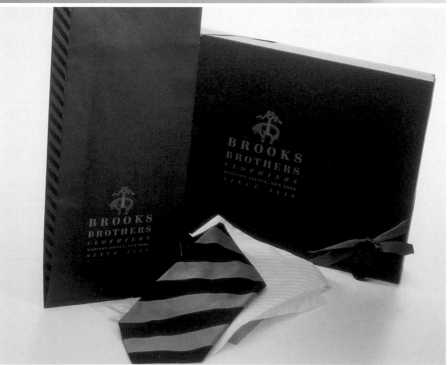

Bags, Boxes, & Tags

The triangle-shaped bottom makes for an "exceptional" bag,
just as it states above the logo.

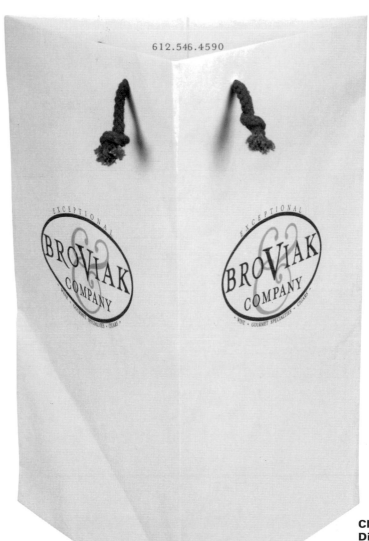

Client Broviak
Distributor Gift Box Corporation of America
Manufacturer Keenpac North America Limited

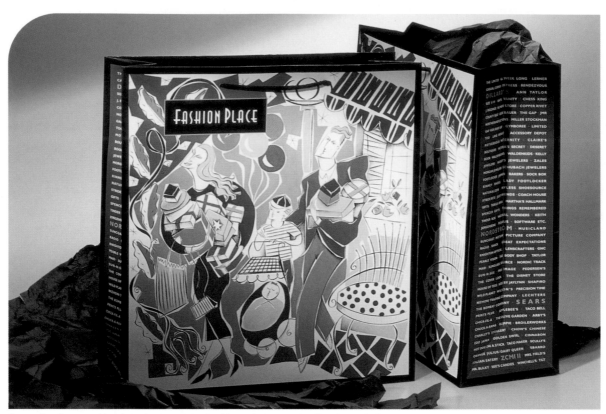

Sweeping lines and bright colors convey the idea of a hectic but fruitful day of shopping.

Client Fashion Place Mall
Design Firm Harris Volsic Creative
Creative Director David Volsic
Illustrator Rob Blanchard
Manufacturer Commonwealth Packaging Co
Paper/Printing 4 colors plus matte coating

Client Mondi
Manufacturer Keenpac North America Limited

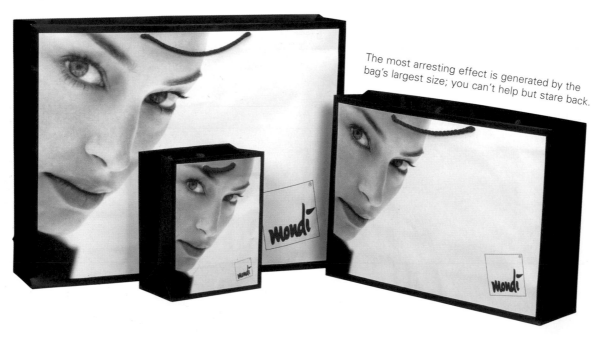

The most arresting effect is generated by the bag's largest size; you can't help but stare back.

Client The Willows
Design Firm SJI Associates
Designer Jill Vinitsky
Distributor Image Packaging
Manufacturer Keenpac North America Limited

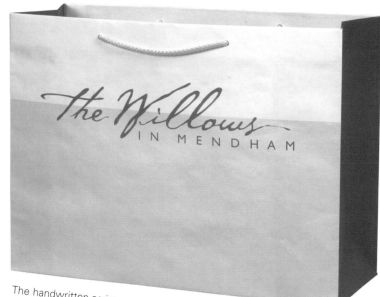

The handwritten script and shades of sherbet green convey the charm of bygone American coastal towns.

Client Gelo
Design Firm Tangram Strategic Design
Art Director/Designer Enrico Sempi
Paper/Printing Fedrigoni ivory laid paper; Rotoffset

The serif lettering of the name of the tailor's store is set simply in the background of a rich red matte field.

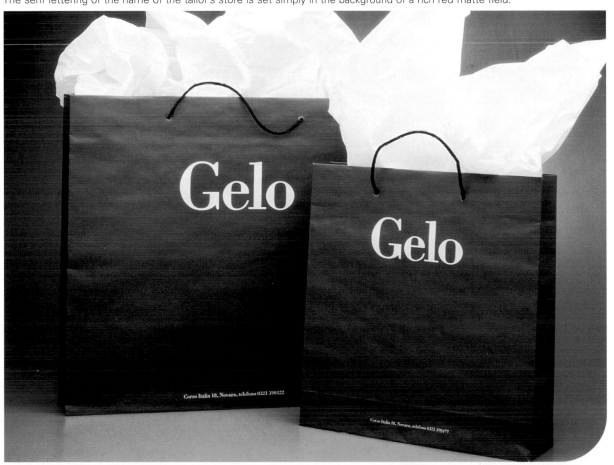

Client
Armani Exchange
Distributor
Duro Bag Manufacturing Company
Paper/Printing
Duro Duet Paper tinted on both sides
with a clothesline handle

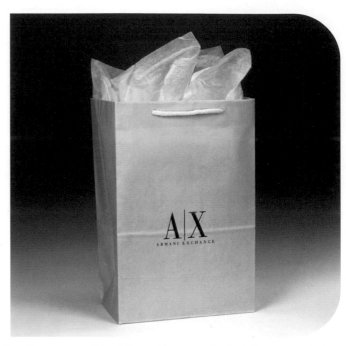

Although very simple, the thick rope handle adds a sense of durability and luxury to the fine elementary design.

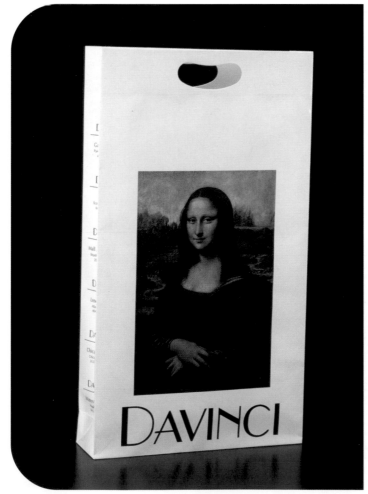

Client Da Vinci
Distributor Design Packaging
Manufacturer Keenpac North America Limited

What image conveys Leonardo da Vinci more than
the ambiguous Mona Lisa?

Bags, Boxes, & Tags

To update the 150-year-old crest of America's oldest leather goods manufacturer with the quiet elegance of the 1990s, designers streamlined the original, more elaborate design. The logo won a Certificate of Typography Excellence from the Type Directors Club in 1996.

Client
Mark Cross
Design Firm
Desgrippes Gobé
& Associates
Design Director
Frances Ullenberg

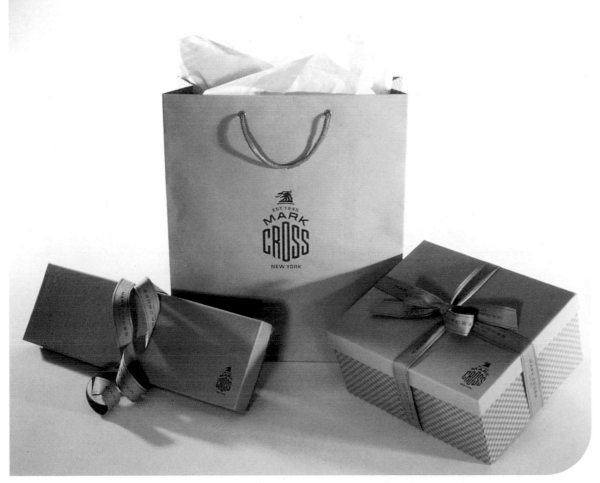

Client Troy
Design Firm hello studio
Art Director/Designer Helene Silverman
Manufacturer Ad Lib Sales, Ltd.
Sticker Printing Lehman Brothers

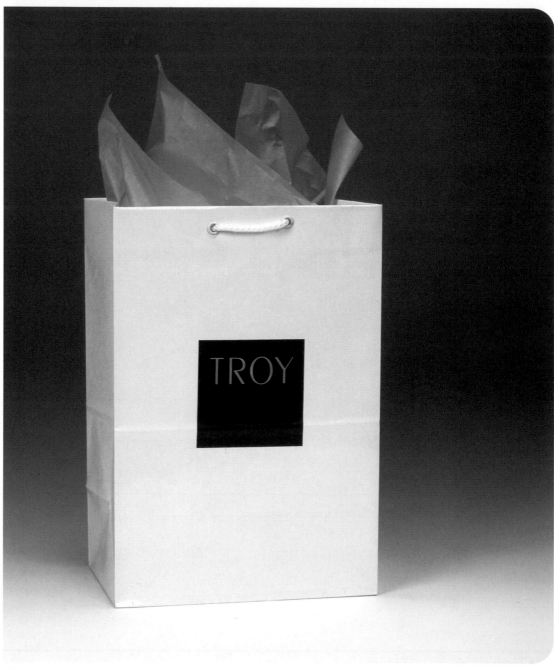

The standard, heavy-stock glossy bag comes in several sizes and accommodates substantial loads with its plastic grommets and thick nylon cording.

Client Melissa Neufeld
Design Firm After Midnight
Art Directors Kathryn Klein and
Tim McGrath
Designers Tim McGrath, Dave Shepherd,
and Andrew Mahoney
Illustrator Tim McGrath

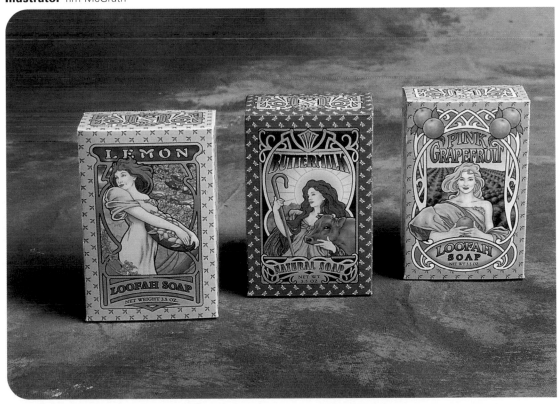

The sensuous, undulating lines on the
soapboxes bring to mind the image of water
flowing into a bath while the pictures recall
old-world romance.

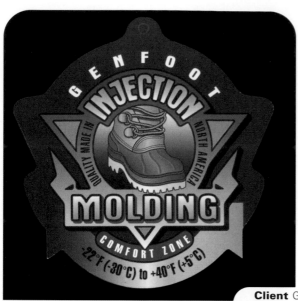

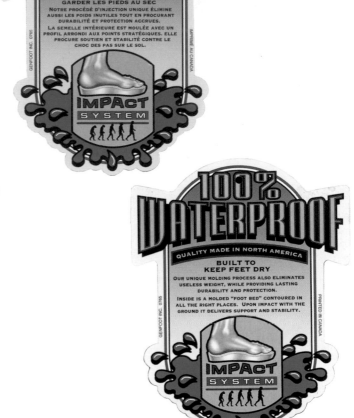

Client Genfoot
Design Firm After Midnight

Genfoot
Injection Molding™
utilizes state-of-the-art machinery and technology to make the molded foot parts of these boots waterproof and durable, providing traction and flexibility without useless weight.

A la fine pointe de la technologie, notre procédé *Genfoot Injection Molding* MD assure l'étanchéité, la durabilité, la traction et la flexibilité de la chaussure moulée, sans pour autant y ajouter du poids.

◄ -22°F (-30°C) to +40°F (+5°C) ►

Testing has proved these materials work together to keep feet comfortable in the temperature range shown above. Other factors will also affect warmth, such as one's circulation, activity level, and quality of sock and outer wear.

Les tests ont prouvés que ces matériaux gardent les pieds confortables dans l' intervalle de température ci-haut. D'autres facteurs peuvent influencer le confort, soit la circulation sanguine, le niveau d'activité et la qualité des chaussettes et survêtements.

PRINTED IN CANADA X3972 IMPRIMÉ AU CANADA

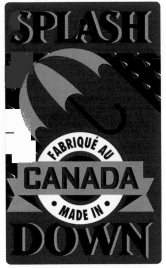

SPLASH

QUALITY BUILT **IN CANADA**
UNE QUALITÉ CONSTRUITE AUX CANADA

100% WATERPROOF PROTECTION
PROTECTION 100% IMPERMÉABLE

LIGHTWEIGHT, SEAMLESS CONSTRUCTION
FABRICATION LEGERE, DE UNE PIECE

DURABLE OUTSOLE FOR LONG WEAR
SEMELLE DUREABLE POUR LONGTEMPS

TREAD DESIGN HELPS PREVENT SLIPPING
ON WET SURFACES
LE DESIGN DE LA SEMELLE EST ANTI-DERAPANT

GENFOOT, INC.
MONTRÉAL, QUEBEC, CANADA

DOWN

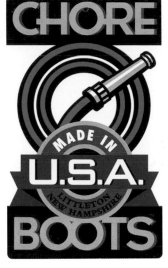

CHORE

QUALITY BUILT **IN THE U.S.A.**

100% WATERPROOF PROTECTION

LIGHTWEIGHT, SEAMLESS CONSTRUCTION

TOUGH, DURABLE OUTSOLE FOR LONG WEAR

SPECIAL TREAD DESIGN DELIVERS GOOD
TRACTION ON A VARIETY OF SURFACES

EXTRA SHAFT HEIGHT FOR LOWER
LEG PROTECTION

A QUALITY PRODUCT FROM
GENFOOT AMERICA INC.
LITTLETON, NEW HAMPSHIRE

BOOTS

SHRIMP

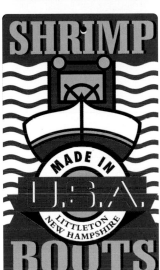

QUALITY BUILT IN THE U.S.A.

RELIABLE COMPANIONS
FOR WATER-BOUND FEET

100% WATERPROOF PROTECTION

LIGHTWEIGHT, SEAMLESS CONSTRUCTION

TOUGH, DURABLE OUTSOLE FOR LONG WEAR

TREAD DESIGN HELPS PREVENT SLIPPING
ON WET SURFACES

EXTRA SHAFT HEIGHT FOR LOWER
LEG PROTECTION

A QUALITY PRODUCT FROM
GENFOOT AMERICA INC.
LITTLETON, NEW HAMPSHIRE

BOOTS

The hangtags and boxes for a variety of footwear products employ bold graphics and colors
that are not only eye-catching but illustrate the intended purpose of each product.

Client Crabtree & Evelyn
Design Firm Crabtree & Evelyn
Art Director/Designer Jeff Woods
Distributor Atlas Paper Co.
Manufacturer Handelok Bag Company
Paper/Printing Six-color Gravure on CIS

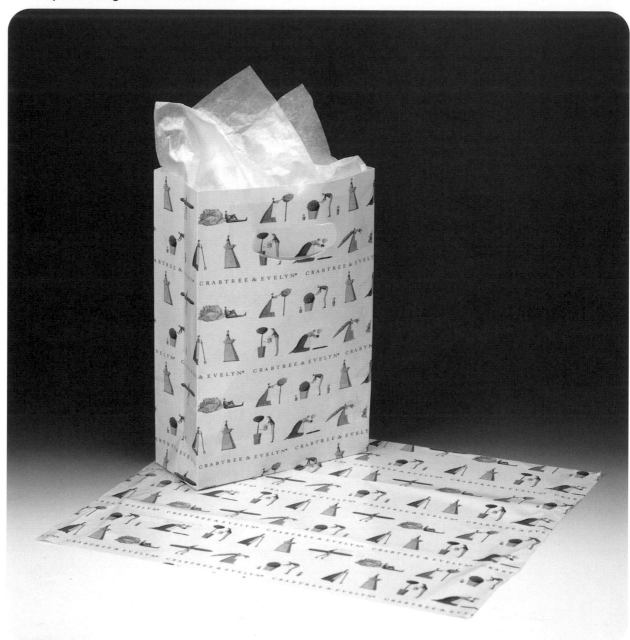

Gravure printing on two different paper stocks produced finished products that look identical. The wrapping paper and bags were used to launch Crabtree & Evelyn's gardener line of products.

Client Tommy Bahama
Designer Foundation
Distributor Packaging Specialties
Manufacturer Bonita Pioneer Packaging

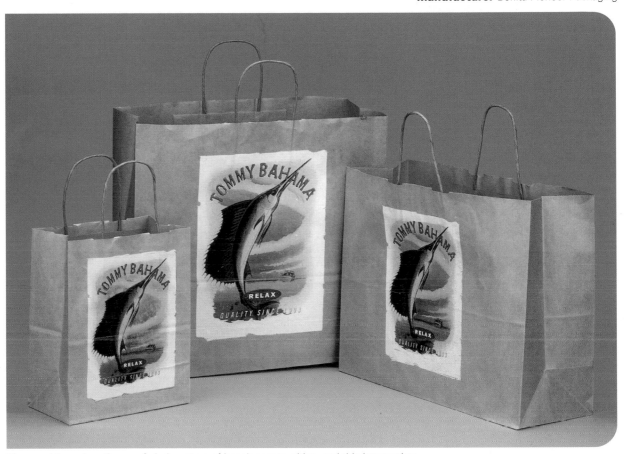

The graphic evokes the sun-faded posters of beach communities, and this impression is fitting with the apparel company's mantra of "relax."

Client Billy Blue
Design Firm Brad Thomas Design
Art Director/Designer/Illustrator Brad Thomas
Distributor Conifer/Crent Company
Manufacturer/Paper/Printing
Keenpac North America Limited

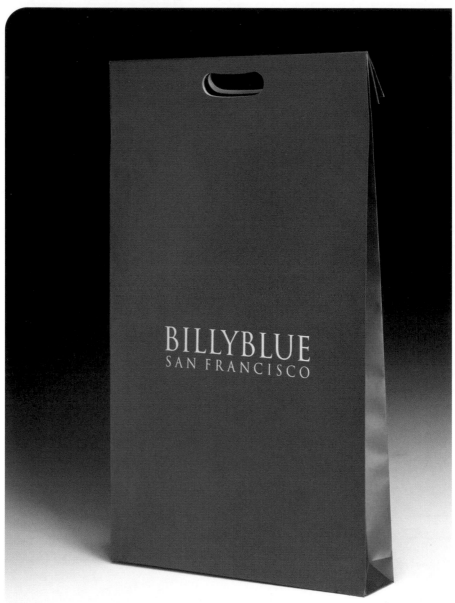

The bag's shimmer and unique shape
combine for a striking effect.

The die-cut tag affixes to sportswear and regular attire; the special effects include screens of fabric patterns printed on the tag's reverse side.

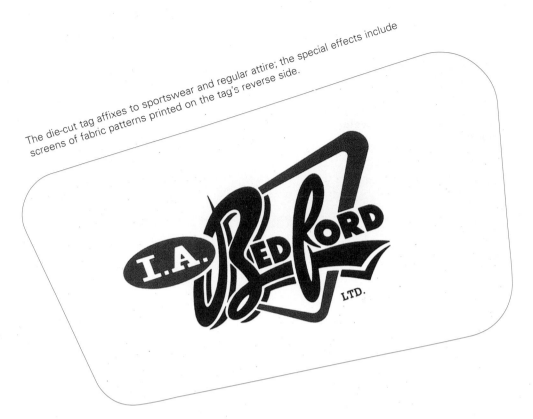

Client I. A. Bedford
Design Firm Sayles Graphic Design
Art Director/Designer John Sayles
Paper/Printing Graphika natural; offset printing

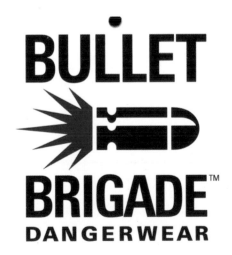

Client Bullet Brigade Dangerwear Swat Team
Design Firm Bullet Communications
Creative Director/Designer/Illustrator
Tim Scott

WEAR YOUR BULLETS DON'T SHOOT THEM!

The hangtag was conceived to complement the clothing line designed by Bullet Communications. Although the name may appear to be rather tough, the motto "Wear Your Bullets/Don't Shoot Them" assures the consumer of the designer's clever and harmless intentions.

BULLET BRIGADE DANGERWEAR
AND ITS LOGO ARE TRADEMARKS OF
BULLET COMMUNICATIONS, INC./CHICAGO

Lifestyle & Well-Being

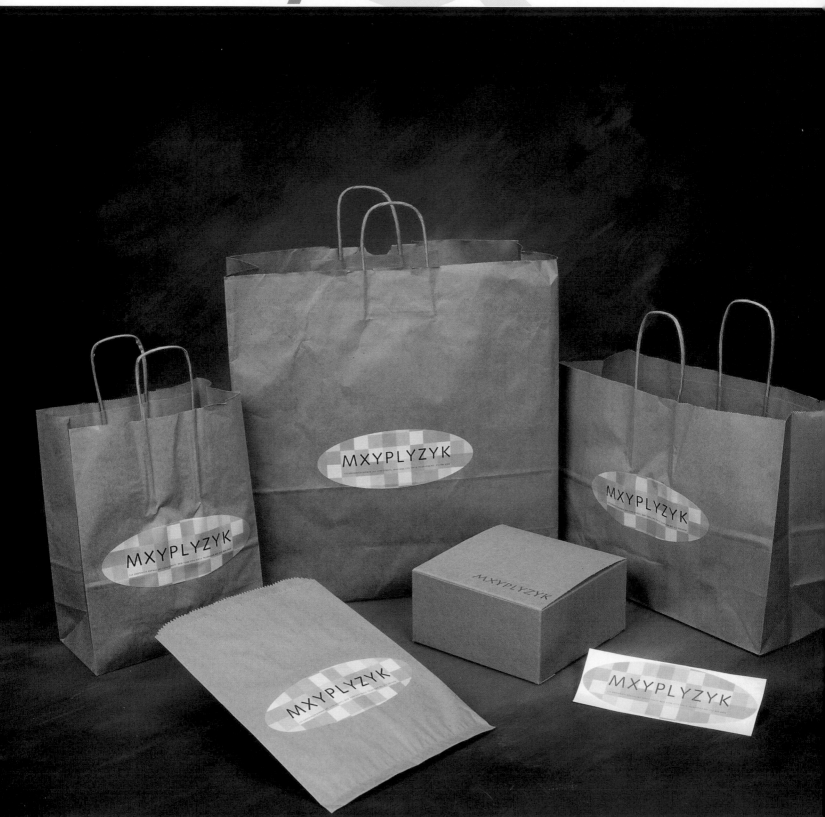

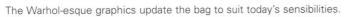
The Warhol-esque graphics update the bag to suit today's sensibilities.

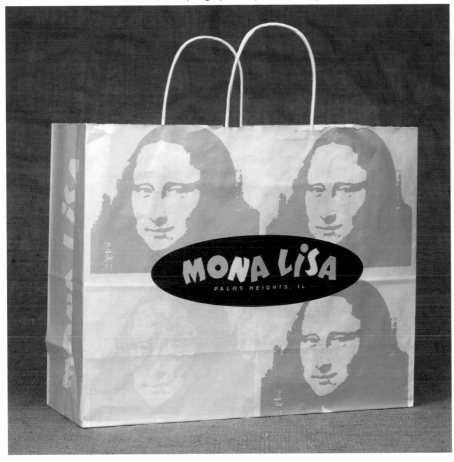

Client Mona Lisa
Art Director Jim Parker
Designer Jodi Schwartz
Distributor Howard Decorative
Manufacturer Bonita Pioneer Packaging

Client Mxyplyzyk
Designer Brian Fingeret
Paper/Printing NY Label

The logo's clean, updated colors reflect the sensibility
of mid-century inspiration.

Client Bullet Communications
Design Firm Bullet Communications
Creative Director/Designer Tim Scott
Illustrator Dan Cosgrove

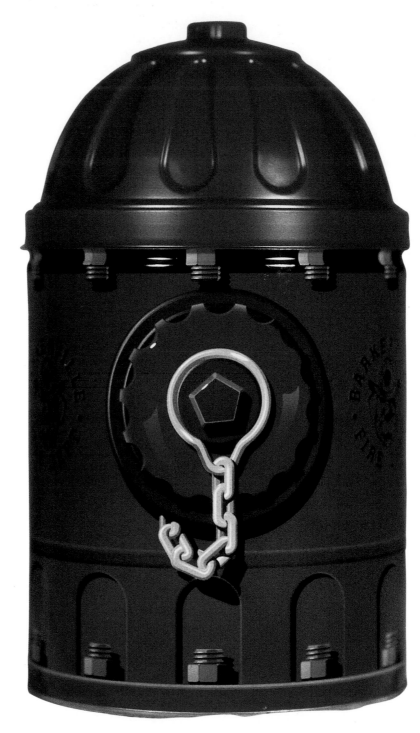

The novelty pet gift product, a dog biscuit container, effectively
combines humor and functionality in one canine-savvy package.

The unadorned packaging
suits the sleek containers well.

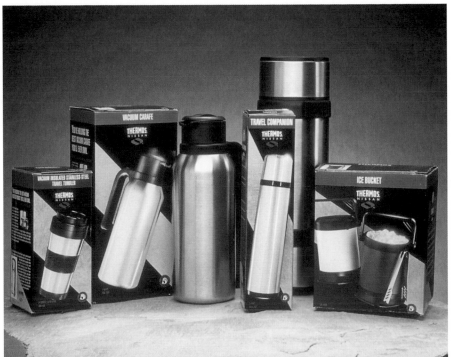

Client
Nissan/Thermos Corporation
Design Firm
Gardner Design
Art Director
Bill Gardner
Designer
Karen Hogan
Photographer
Paul Chauncey

Client
Tails of the City
Design Firm
Creative Division
of Max Pack
Designer
Kit Bauer
Distributor
Max Pack
Manufacturer
Keenpac North
America Limited

The three-color bag for an
upscale doggie boutique uses
spot gloss varnish over matte
lamination, which brings out
the brilliant red die-cut
hydrant as the focal point.

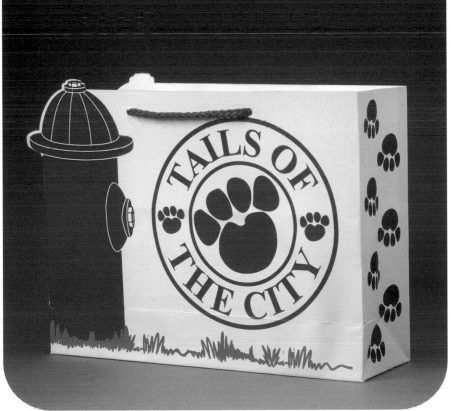

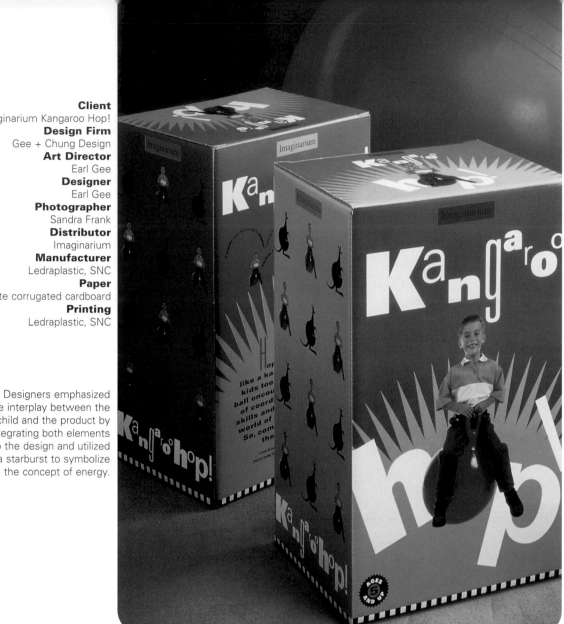

Client
Imaginarium Kangaroo Hop!
Design Firm
Gee + Chung Design
Art Director
Earl Gee
Designer
Earl Gee
Photographer
Sandra Frank
Distributor
Imaginarium
Manufacturer
Ledraplastic, SNC
Paper
E-flute corrugated cardboard
Printing
Ledraplastic, SNC

Designers emphasized the interplay between the child and the product by integrating both elements into the design and utilized a starburst to symbolize the concept of energy.

Client
Carpenter Co./Travel Ware Pillow
Design Firm
Communiqué Marketing
Artist
William S. Cross

The artwork evokes the idea of decals found on steamer trunks at the turn of the century.

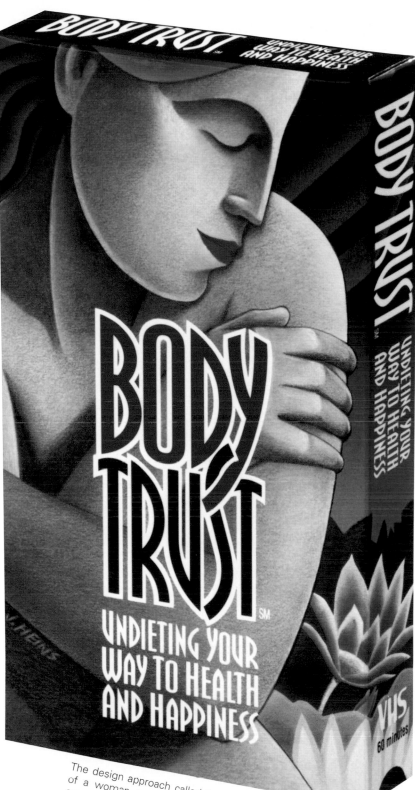

Client Body Trust
Design Firm Heins Creative, Inc.
Creative Director Joe Heins
Designer Joe Heins

The design approach called for a tightly cropped illustration of a woman embracing herself in an obvious gesture of contentment.

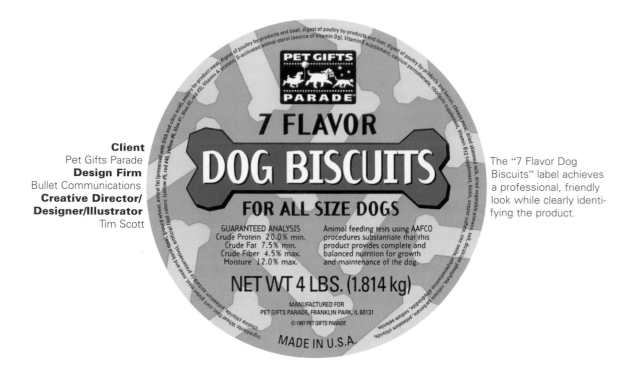

Client
Pet Gifts Parade
Design Firm
Bullet Communications
**Creative Director/
Designer/Illustrator**
Tim Scott

The "7 Flavor Dog Biscuits" label achieves a professional, friendly look while clearly identifying the product.

The new brand identity is bold and uses a cloud icon to communicate the pillowy softness of the product.

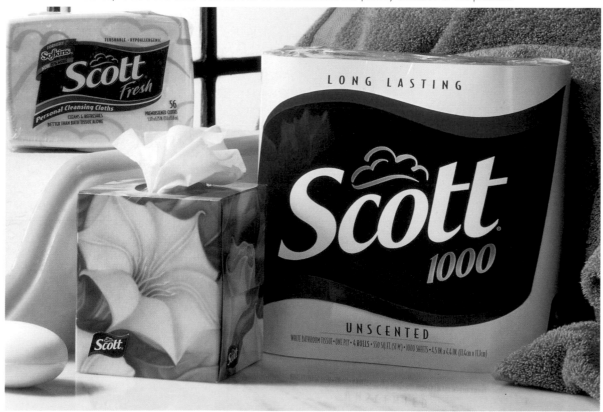

Client Scott Paper
Design Firm Lipson-Alport-Glass & Associates
Art Director Howard Alport

Client Ariel
Design Firm Lipson-Alport-Glass & Associates
Art Director Howard Alport

The goal was to retain simplicity, shelf presence, and character. The effectiveness of the design rides on the current appreciation for retro-1950s styles.

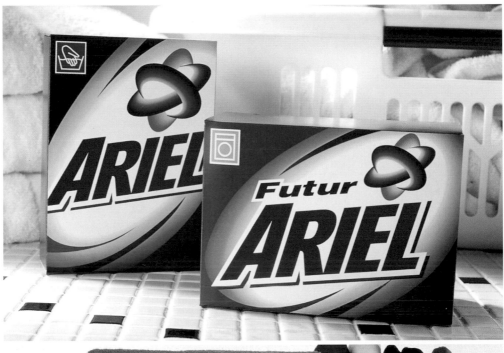

The bold, hip colors and large sans serif branding establish super hero strength, which is a striking statement about the detergent's power to remove dirt.

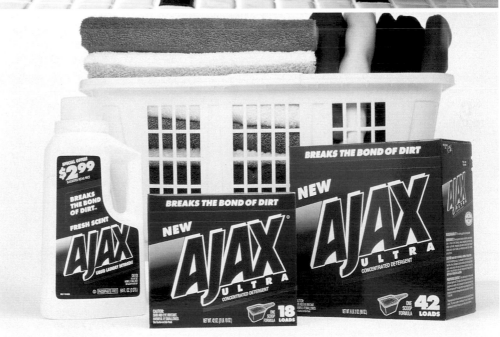

Client Ajax
Design Firm Berni Design
Art Director Mark Eckstein
Distributor Colgate-Palmolive Company

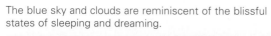

The blue sky and clouds are reminiscent of the blissful states of sleeping and dreaming.

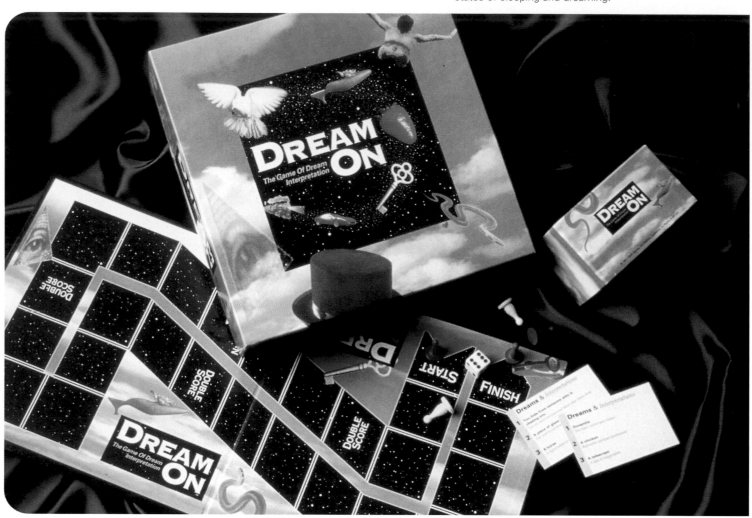

Client Dream On
Design Firm Addis Group
Art Director Steven Addis

The tag was designed for serious dog owners who want to treat their pets to all-natural biscuits that contain buffalo liver. The intention was to evoke an image of Native American handmade goodness.

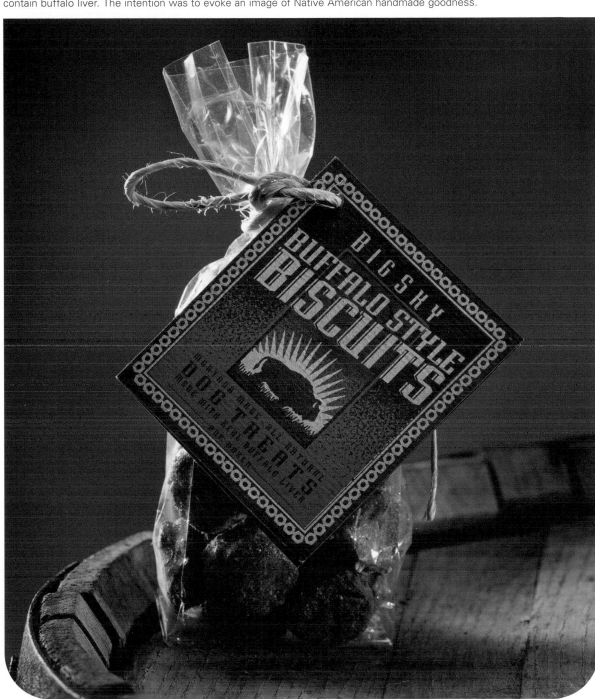

Client
Gormutt Doggie Delights
Dog Biscuits
Design Firm
Heins Creative
Creative Director
Joe Heins
Designer
Joe Heins

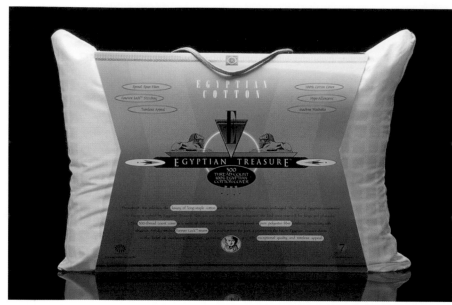

Client Carpenter Co./
Egyptian Treasure Pillow
Design Firm
Communiqué Marketing
Artist Gia Owens

The illustration depicts the strong geometric lines of the ancient Egyptians'
artwork and the handle adds a touch of convenient distinction.

The image communicates the novelty of utilizing a material
that is commonly used for clothing in home accessories as well.

Client
Carpenter Co./Jersey Knit Pillow
Design Firm
Communiqué Marketing
Artist
Scott Lewis

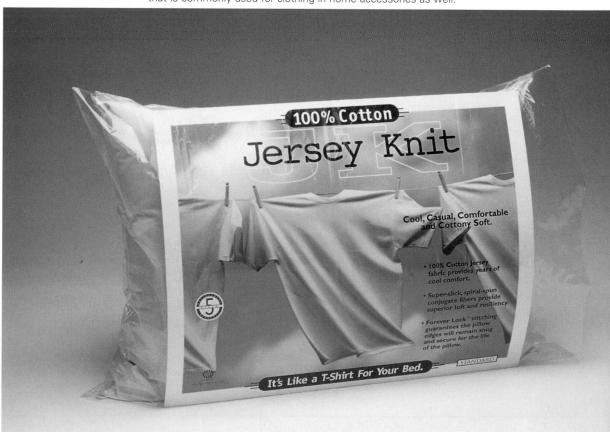

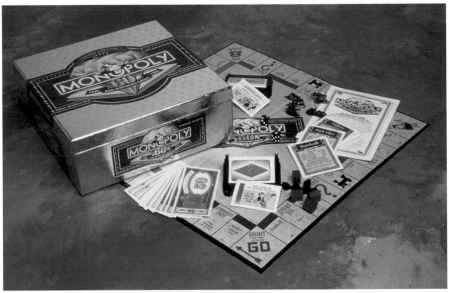

Client Parker Brothers
Design Firm After Midnight
Art Director Kathryn Klein
Designers Tim McGrath
and Kathryn Klein

The Monopoly box is a flashy celebration in honor of the venerable
board game's 60th anniversary.

The earthy design complements the fibers and texture of the stationery, which is made of tobacco leaves.

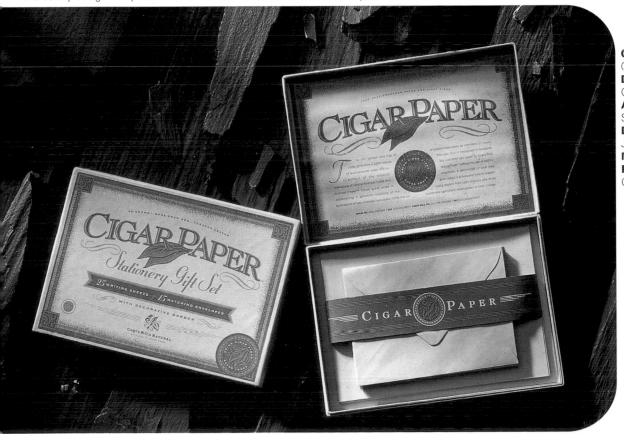

Client
Costa Rica Natural Paper
Design Firm
Greteman Group
Art Director
Sonia Greteman
Designer/Illustrator
James Strange
**Manufacturer/
Paper/Printing**
Costa Rica Natural Paper

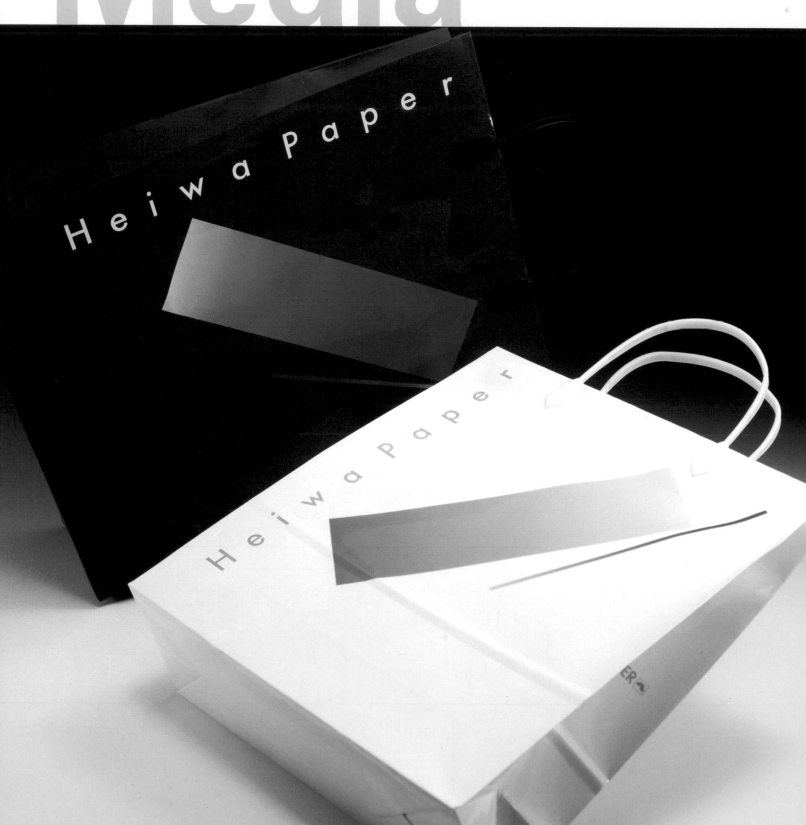

Media

Client Fraser Papers
Design Firm Little & Company
Art Director Paul Wharton
Designer Kathy Soranno
Manufacturer Modern Arts Packaging
Photographer Frederick Broden

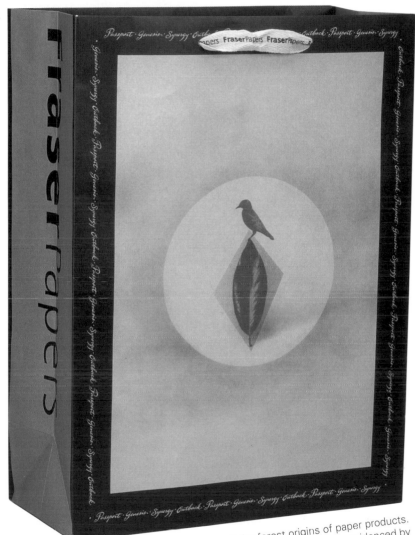

The images and color palette recall the forest origins of paper products. In creating the bag, great attention was paid to detail, as is evidenced by the appearance of the client's name on the handle.

Client
Heiwa Paper Co., Ltd.
Design Firm
Package Land Co. Ltd.
Art Director/Designer
Yasuo Tanaka

The geometric design is interesting on both the white and deep blue backgrounds.

Client S. D. Warren Paper
Design Firm Siegel & Gale
Art Director Jason Glassner
Manufacturer Modern Arts Packaging
Paper/Printing 100 lb./270 gsm lustro gloss cover

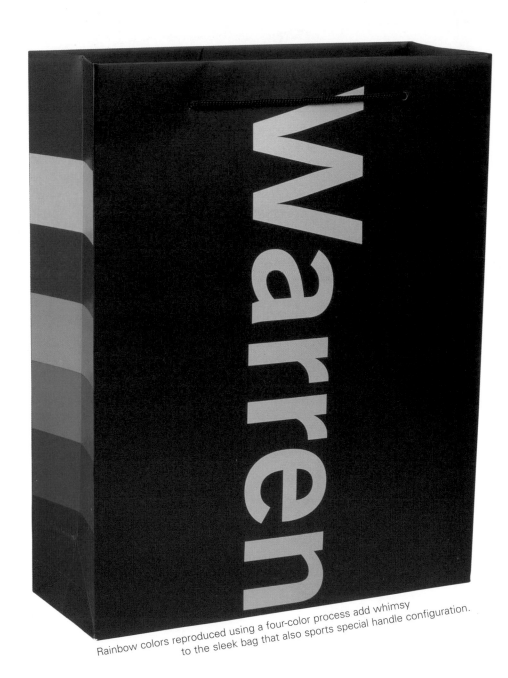

Rainbow colors reproduced using a four-color process add whimsy to the sleek bag that also sports special handle configuration.

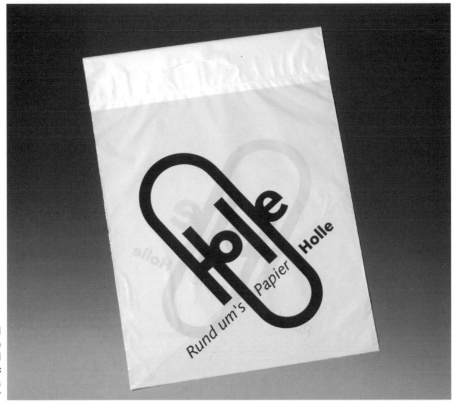

Client Georg Holle:
Papier, Büro,
Schreibwaren (stationery)
Design Firm Buttgereit
& Heindenreich, Strategie–
Kommunikation–Design
Art Directors/Designers
Michael Buttgereit and
Wolfram S. C. Heindenreich
Manufacturer
Heukäufer Folien, Herten
Paper/Printing Flexo-Druck

Designers combined
the name of the shop
with a paper clip and added
the phrase *Rund um's
Papier*, which means
"all-around paper."

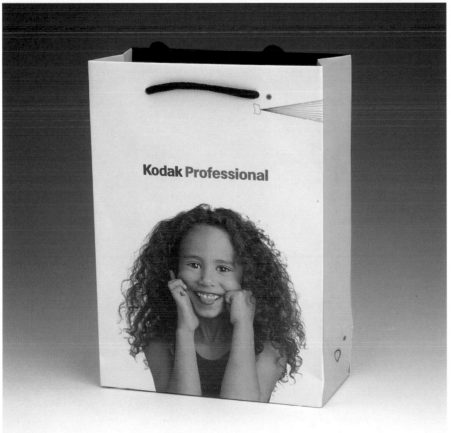

Client Kodak
Design Firm Saatchi
& Saatchi Business
Communications
Manufacturer Modern
Arts Mexico
Paper/Printing 150 gsm;
four-color process; matte finish
and lamination

The photo on the bag
is playful and its fine repro-
duction quality emphasizes
the high level performance
of Kodak film. The pattern
inside mimics photography
studio lights.

Client CBS
Distributor The Metro
Packaging Group, Inc.
Manufacturer Keenpac
North America Limited
Paper/Printing C25 litho
paper with matte film lamina-
tion finish; one-color offset
hot-stamped with silver

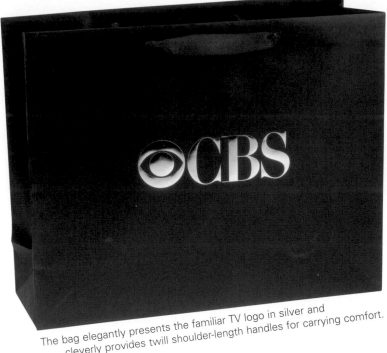

The bag elegantly presents the familiar TV logo in silver and
cleverly provides twill shoulder-length handles for carrying comfort.

Client The Independent Project Shop Bag
Design Firm Independent Project Press
Art Director Bruce Licher

Client
National Geographic
Design Firm
National Geographic
Distributor
Atlas Paper Co.
Manufacturer
Handelok Bag Company
Paper/Printing
Printed two-color on natural
kraft

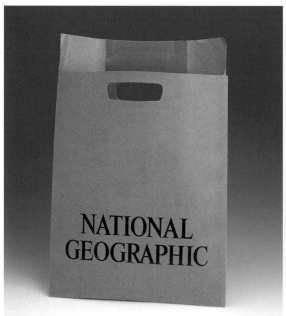

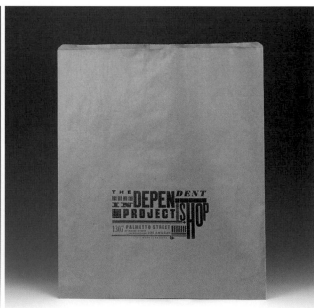

Displaying its subtle but highly recognizable logo, the
bag is utilized at retail locations to distribute literature
and promotional materials as part of National
Geographic member kits.

The industrial feel of the logo fits well with the natural kraft
paper, while the slight metallic sheen prevents the bag from
looking too thrifty.

Client Strathmore Papers
Design Firm Williams and House
Art Director Pam Williams
Designer Michael Gunselman
Illustrator Archive illustrations from Strathmore
Manufacturer Modern Arts Packaging
Paper/Printing Strathmore Grandee; various colors

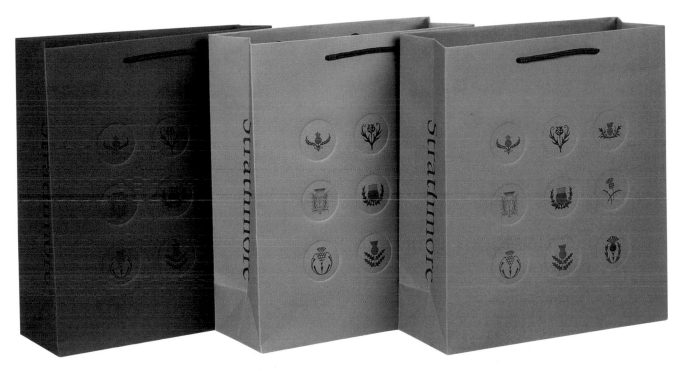

The custom shopping bag was crafted with the client's own premium cover paper line and text. Featuring the debossing of different versions of the company thistle, they are designed to hold Strathmore promotional materials and paper samples for graphic designers.

The logo's glowing effect was achieved with Adobe Photoshop. An upscale, icon-like look was conceived to symbolize the energy of VH1 programming.

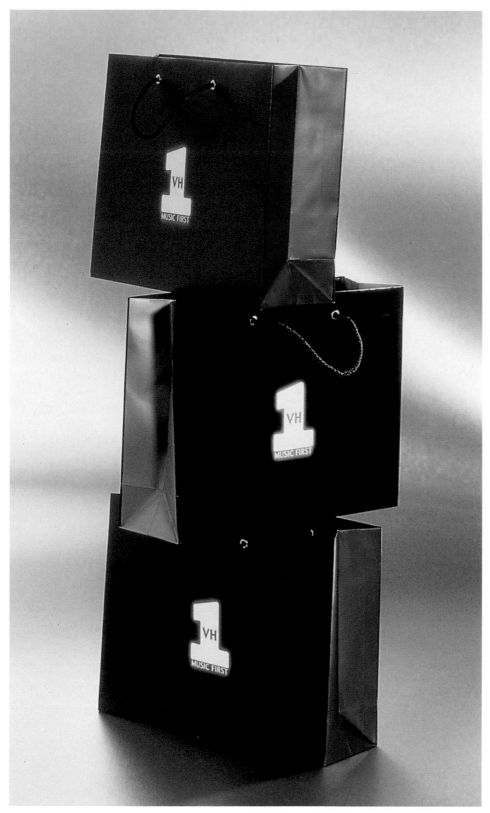

Client VH1
Design Firm Parham Santana Inc.
Art Directors Lori Ann Reinig (Parham Santana) and Dean Lubensky (VH1) Digital
Photo Composition Derek Beecham
Manufacturer Commonwealth Packaging
Paper/Printing 165g mount lamination; coated two sides on offset sheet

Designed for the store on New York's bustling Madison Avenue, the bag hints at the romance and beauty of the big city at night.

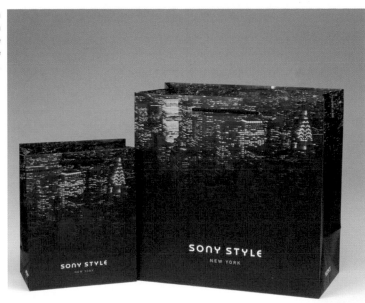

Client
The Sony Style Store, New York
Design Firm
Frankfurt Balkind Partners
Art Director
Kent Hunter
Designer/Illustrator
Stephen Hutchinson
Manufacturer
S. Posner Sons Inc.
Paper/Printing
Tritone printing on matte laminate

Original artwork from a painting by artist Kenny Scharf makes a guest appearance on the Sony bag.

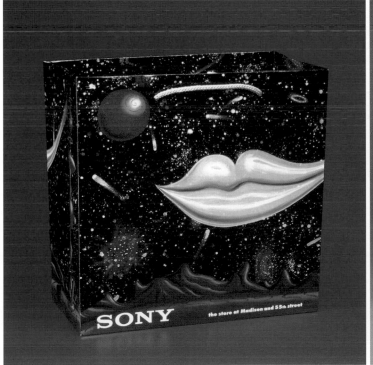

Client The Sony Style Store, New York
Design Firm Sony Plaza Creative
Creative Director Christine Belich
Designer Tammy Stubbs
Artist Kenny Scharf
Manufacturer S. Posner Sons Inc.

The "Wild Thing" character, created by author/illustrator Maurice Sendak, and digitally composed art of New York buildings are recognizable illustrations that are combined with a famous brand name.

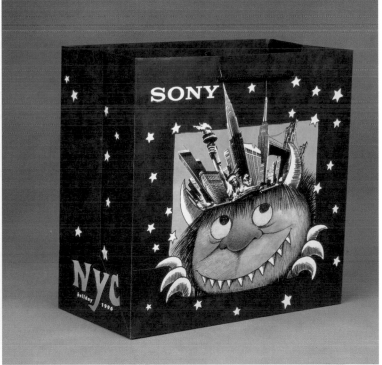

Client The Sony Style Store, New York
Design Firm Sony Plaza Creative
Creative Director Christine Belich
Designers Tammy Stubbs and Scott Sinclair
Illustrator Maurice Sendak
Manufacturer S. Posner Sons Inc.

Client FOX Sports Direct
Design Firm Swieter Design U.S.
Art Director John Swieter
Designer Julie Poth
Manufacturer Jarvis Press

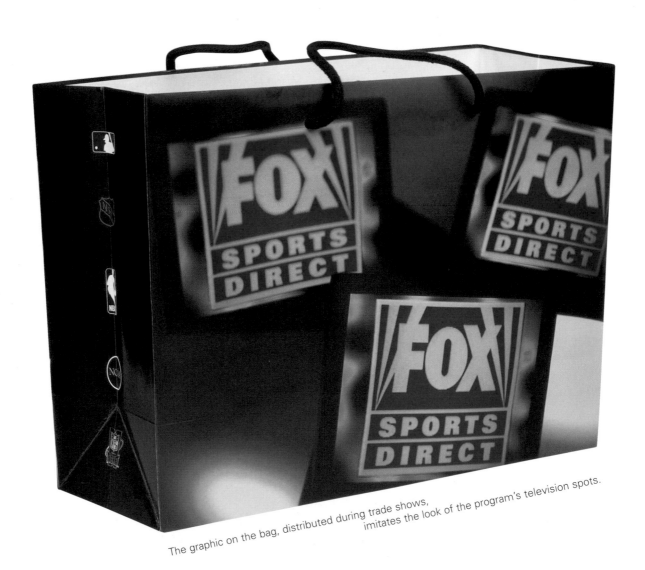

The graphic on the bag, distributed during trade shows, imitates the look of the program's television spots.

Client Mohawk Paper Mills Navajo
Design Firm Aurora Designs
Designer Jennifer Ett Wilkerson

The shopping bag demands attention with its large lettering and bold, hip colors. The design is a wonderful surprise since the client's name unfortunately lends itself easily to cliché.

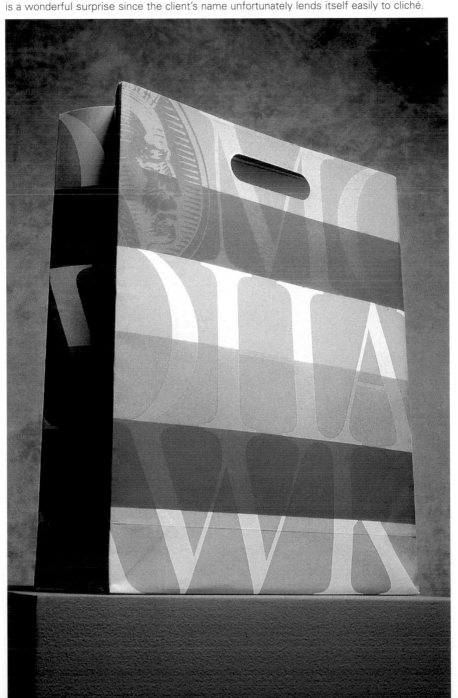

Clients Autodesk, Claris Corporation, Netscape,
Kodak Photo, Teneron
Design Firm Neumeier Design Team
Designers Marty Neumeier, Christopher Chu,
Heather McDonald
Paper/Printing 18 pt. SBS Board

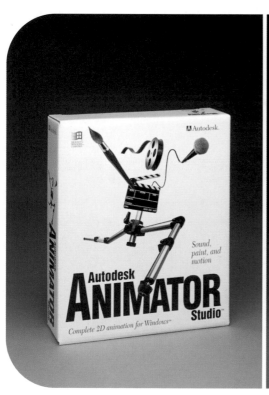

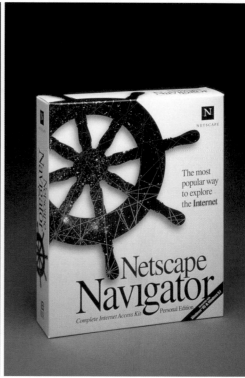

By depicting the elements of the programs in illustrations set on stark fields, the team has designed packaging for computer software that is not only eye-catching but ingenious.

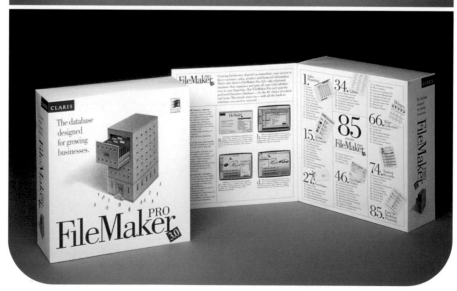

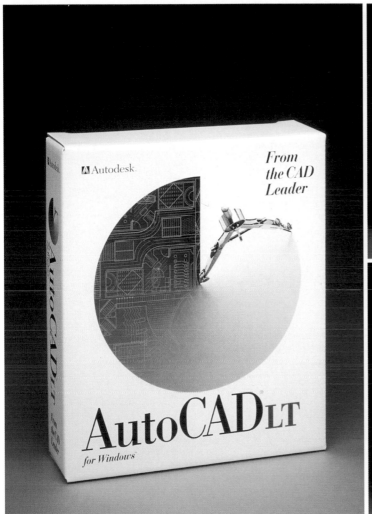

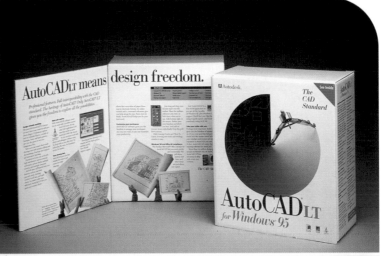

Designers took the vertical identity and incorporated it into the packaging program's clean concept.

The images on the CD game boxes convey the unexpected surprises and fun associated with trivia games.

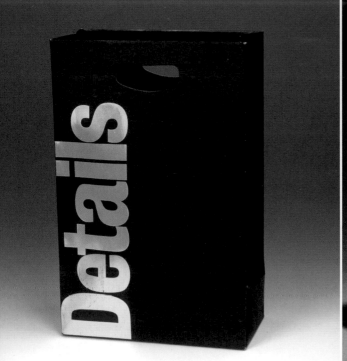

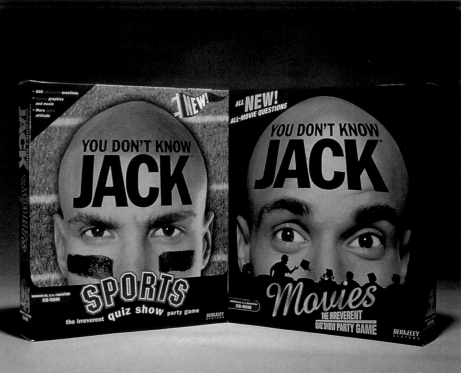

Client Details
Design Firm Details In-house
Art Director Michele Carone
Production Manager Marty Todd
Distributor RTR Packaging Corporation
Manufacturer Keenpac North America Limited

Client You Don't Know Jack
Design Firm Addis Group
Art Director Steven Addis

The media kit/presentation bag that introduces the magazine's new name features a supple rope handle and softly drawn graphics.

After the customer-supplied film was received, the manufacturer magically produced the bags within a one-week time period.

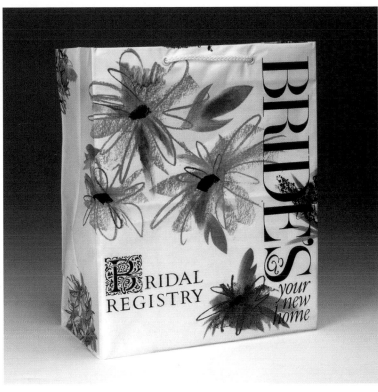

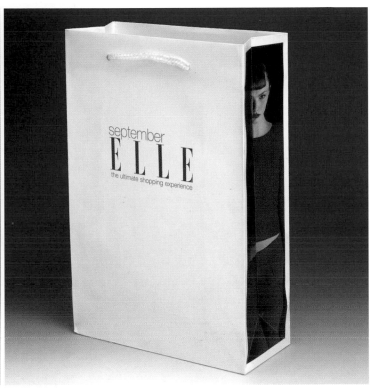

Client *Bride's* & *Your New Home Magazine*
Distributor The Metro Packaging Group, Inc.
Manufacturer Regal/Polypak
Film/Printing Low-density polypropylene film; four-color and one rotogravure printing

Client September *Elle*/Hachette Filipacchi
Design Firm *Elle* In-house
Art Director Rob Nolan
Manufacturer Modern Arts Packaging

The elongated shape is perfect for holding the promotional book posters that are given out to book-sellers at national trade shows.

With its folding top and lavish ribbon, the bag was designed to present the magazine's luxury issue.

Client Condé Nast House & Garden
Design Firm RTR Packaging & Design
Art Director Ron Raznick
Designers Maureen Gillespie and Ron Raznick
Illustrator Maureen Gillespie
Distributor RTR Packaging
Paper/Printing Matte vinyl PVC silkscreened

Design Firm Little, Brown and Company
Art Director Michael Ian Kaye
Designers Michael Ian Kaye and Capo Ng
Manufacturer S. Posner Sons Inc.

The promotional bag's lovely graphic printed on kraft paper evokes a sentimental concern for the environment.

Used throughout their retail stores, the theme of the illustrations is transferred from shopping bags to gift boxes, tags, and tissues. The reusable translucent packaging and the geometric design mirror the scientific and often revealing nature of the Discovery Channel's media programming.

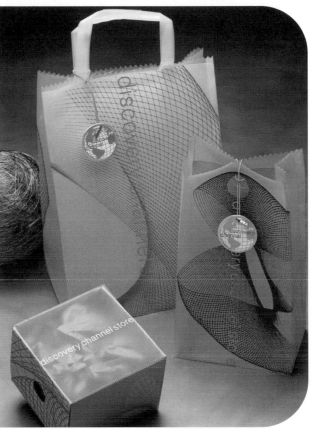

Client Cross Pointe Paper
Designers Ellen Huber and Ted Riley
Design Director Paul Warton
Photographer Hugh Kreschner

Client The Discovery Channel
Design Firm Morla Design
Art Director Jennifer Morla
Designers Jennifer Morla, Angela Williams, and Yoram Wolberger
Bag Manufacturer RG Creations
Box Manufacturer Klearfold Inc.
Paper/Printing Silkscreen on translucent plastic

Food & Spirits

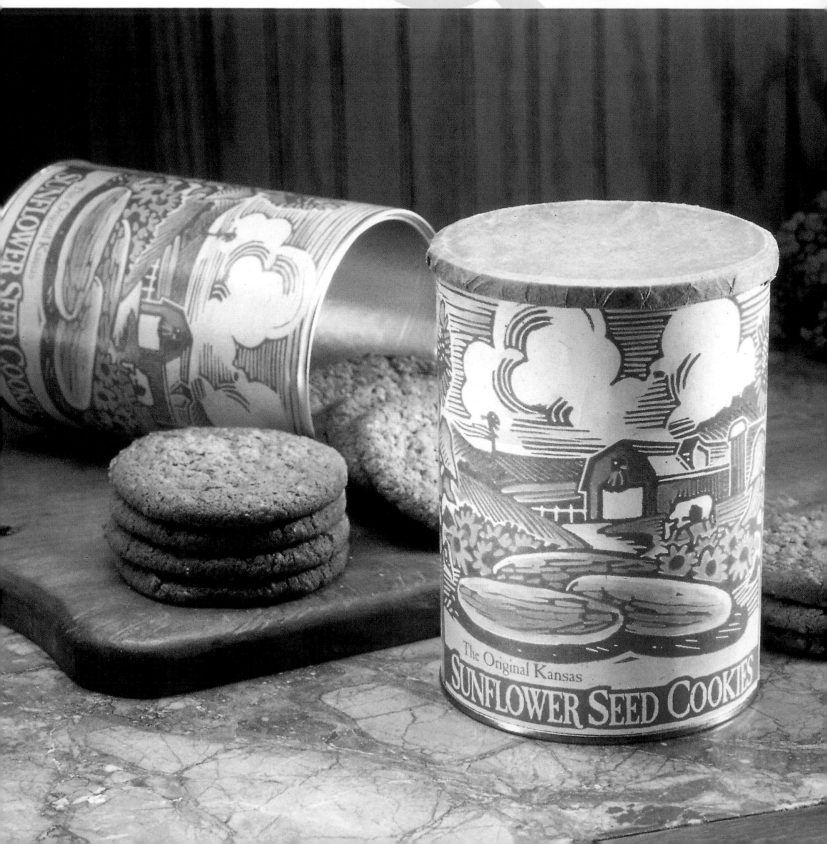

The Original Kansas
SUNFLOWER SEED COOKIES

Casa de Fruta has been a roadside attraction selling fruits and candies since 1908. When the owners started opening stores in regional shopping centers, they decided they needed a more visible retail presence that would still be suggestive of their humble history. The designers created a hand-drawn logotype and applied it to boxes and bags.

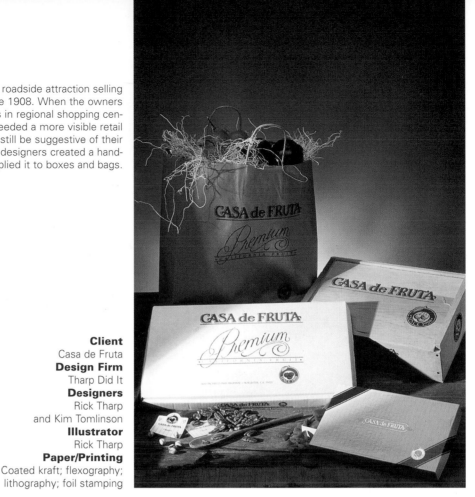

Client
Casa de Fruta
Design Firm
Tharp Did It
Designers
Rick Tharp
and Kim Tomlinson
Illustrator
Rick Tharp
Paper/Printing
Coated kraft; flexography;
lithography; foil stamping

Client Doskocil Incorporated
Design Firm Gardner Design
Art Director Bill Gardner
Designer James Strange

Client Sunflower Seed Cookies/
Earthly Endeavors Bakers
Design Firm Gardner Design
Art Director Bill Gardner
Illustrator La Fleur

The tin's illustration of a farm and barn conveys a sense of old-fashioned goodness.

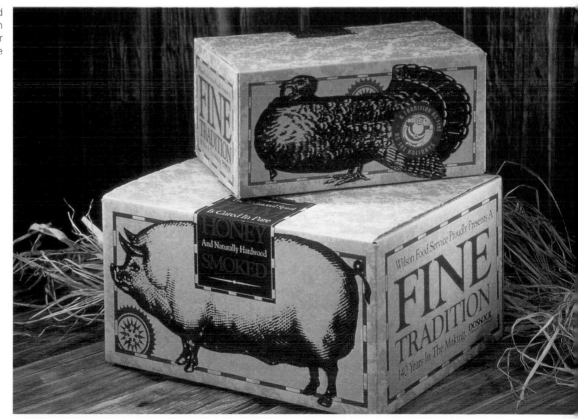

The boxes contain "fine tradition" ham and turkey that can be presented as edible holiday gifts.

Some of the most memorable Marvel Comics characters grace this exciting and dynamic bag; the outline of Spiderman's web, the glow around the letters, and the characters' shadows create images that seem to leap from the bag with super-hero power.

Bright colors and loose brushwork call to mind the carefree beauty of wildflowers.

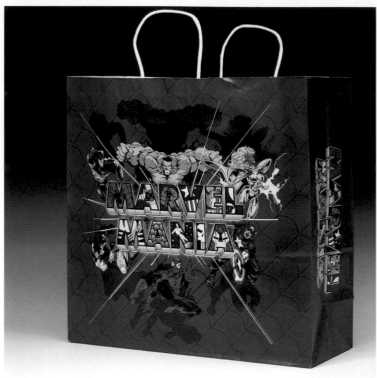

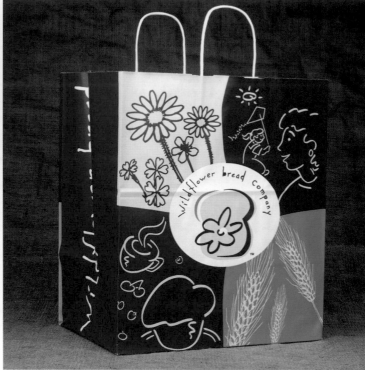

Client Planet Hollywood International
Design Firm Marvel
Art Director/Designer Tracy Leach
Illustrator Marvel
Distributor Schwarz
Manufacturer Interstate Packaging Corporation
Paper/Printing Claycote substrate; flexographic four-color process; UV high gloss varnish produced at 150-line screen with water-based inks

Client Wildflower Bread Company
Designer Estudio Ray
Distributor Reuben Schnieder
Manufacturer Bonita Pioneer Packaging

The bag is the epitome of Palm Beach: pastel and 1950s feminine nostalgia; the smaller size even resembles a purse.

The makers tout this as "the widest bag in the shopping bag industry." Whether this is the truth or not, it is definitely a fun alternative to a plain brown take-out bag.

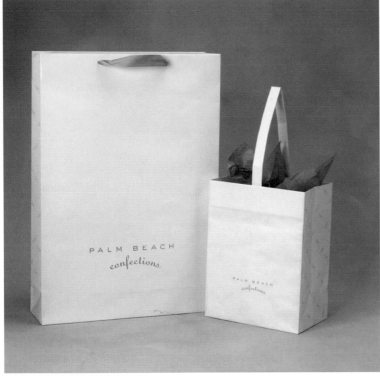

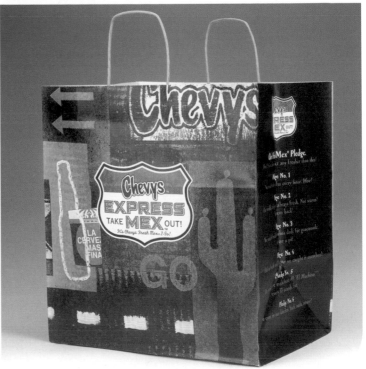

Client Palm Beach Confections
Designer Allison Williams
Distributor Arrow Industries
Manufacturer Keenpac North America Limited

Client Chevys
Distributor Duro Bag Manufacturing Company
Paper/Printing Special 10-inch (25.5-cm) serrated top bag

Client
Caribou Coffee
Distributor
Gift Box Corporation of America
Manufacturer
Keenpac North America Limited

Thanks to the cutouts, the bag is memorable and a bit less expensive to make than other sacks of its kind.

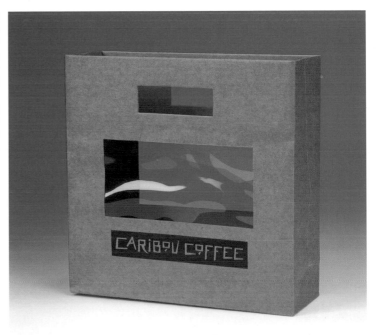

Client Bonita Pioneer
Art Director Jim Parker
Designer Jodi Schwartz
Manufacturer Bonita Pioneer Packaging

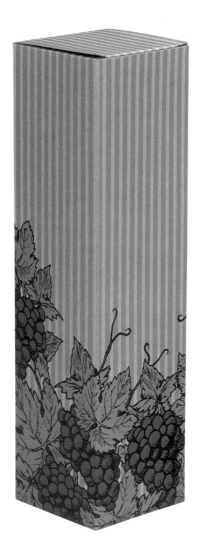

Designed to hold a wine bottle, the stripes add interest while the grapes hint at the contents hidden within.

Client Lake Geneva Coffee
Distributor Howard Decorative
Manufacturer/Paper/Printing Keenpac
North America Limited

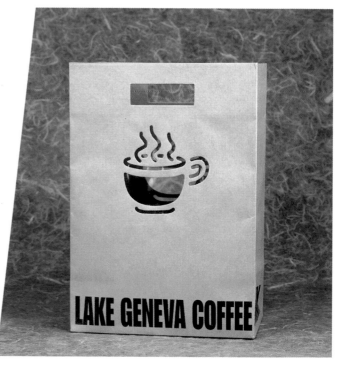

Two bags of coffee can fit in the bag, for which 170 gsm natural kraft paper was chosen and combined with a window covered by film. The die cut is plain yet charming, like the printed name.

Client Boyds Barista Coffee
Designer Robert Bailey
Distributor Unisource
Manufacturer Bonita Pioneer Packaging

Client Cha Meng Group
Design Firm Cha Meng Group
Art Director Virat Suphantarida
Designer Cha Meng Group
Illustrator Jakaphan Petchroon
Distributor/Manufacturer/Paper/Printing
Lucky Star Weaving Co., Ltd.

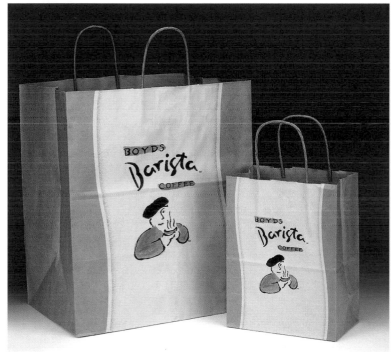

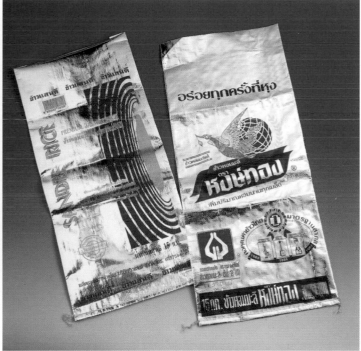

The illustration of the beret-wearing, bohemian coffee shop regular and the use of the word *barista* imply that this place is for the serious caffeine-aholic.

The stunning bag, intended to hold rice, was named "aluminum bag light reflects" by the company. The effect was achieved by laminating the metallized polyetholene woven bag.

Client Doskosil Incorporated
Design Firm Greteman Group
Art Director/Designer/Illustrator James Strange
Paper/Printing Two-color silkscreen

Given a design with 1950s flair, the project is a direct-mail piece for potential clients that outlines information about pizza toppings.

Client
Cristallo
Design Firm
Rocha & Yamasaki
Art Director
Mauricio Rocha
Designers
Rosemari Yamasaki and
Mauricio Rocha
Manufacturer
Gorla
Paper/Printing
Kraft paper; offset printing

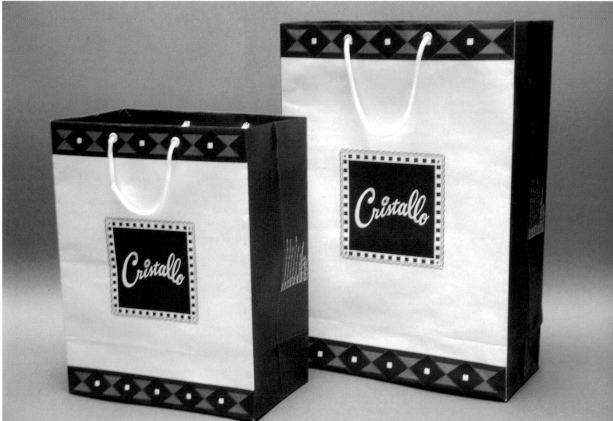

As part of an identity program for a candy store in Brazil, the packages display geometric forms in four pattern colors to add cheer and interest. Designers used a PC 486DX2 with CorelDRAW 6.

Client Caffe Ciao/Kea Lani Hotel
Design Firm Wolf Design II
Art Director/Designer/Illustrator Dawn Wolf
Distributor Conifer/Crent Company
Manufacturer Interstate Packaging Corporation
Paper/Printing Claycote substrate, matte varnish;
flexographic four-color process; one PMS color produced
at 120-line screen with water-based inks

Client The Confection Connection
Design Firm/Distributor Greenebaum Brothers
Manufacturer Bonita Pioneer Packaging
Paper/Printing Two-color, 100% ink coverage printing on claycoat
paper; hot-stamped yellow satin ribbon

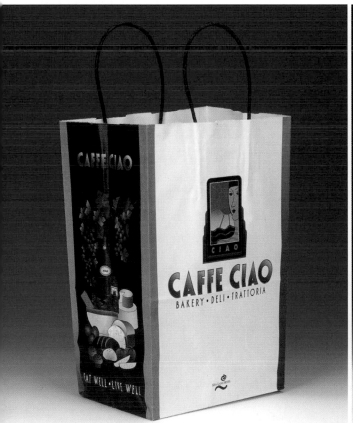

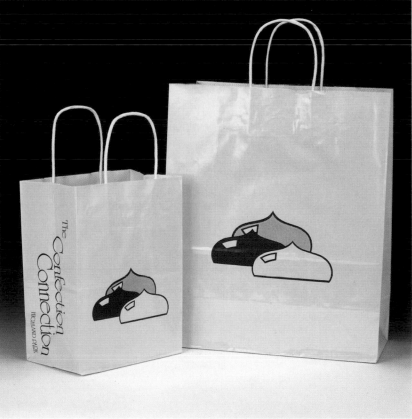

The Modigliani-esque face and sans serif block typeface
convey a sense of worldly travel and Italianate taste that
is appropriate for a trattoria located inside a hotel.

Visible from blocks away, the bright colors and enticing
graphic effectively advertise the wares of the sweet shop.

The typographic treatment of the *B* complements the roughness of the wine stain ring that becomes the *C* in "Cellars."

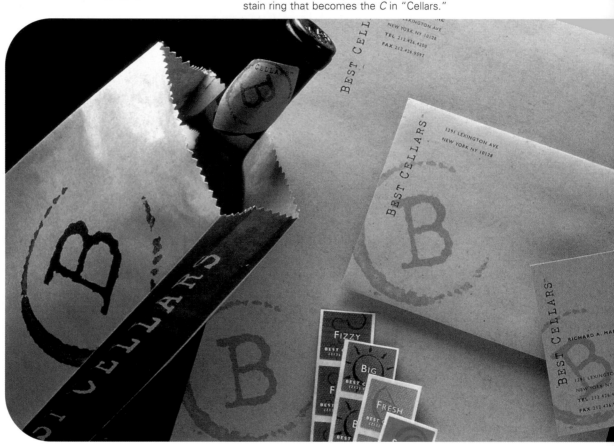

Client
Best Cellars
Design Firm
Hornall Anderson Design
Works, Inc.
Art Director
Jack Anderson
Designers
Jack Anderson, Lisa Cerveny,
and Jana Wilson
Paper/Printing
Kraft paper stock

The logo portrays the fusion of a sphere and a bowl in motion to reflect the restaurant's global menu selections, style, and service.

Client
CW Gourmet/Mondéo
Design Firm
Hornall Anderson
Design Works, Inc.
Art Director
Jack Anderson
Designers
Jack Anderson,
David Bates,
and Sonja Max
Illustrator
David Bates
Paper/Printing
Kraft paper stock

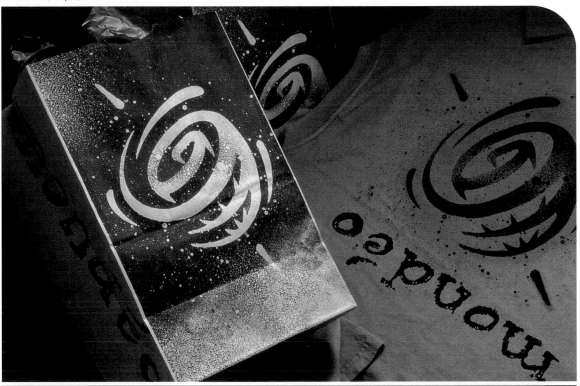

Client
Le Boulanger Bakery Cafés
Design Firm
Tharp Did It
Designers
Rick Tharp and Jean
Mogannam
Illustrator
Rick Tharp
Paper/Printing
Kraft; flexography

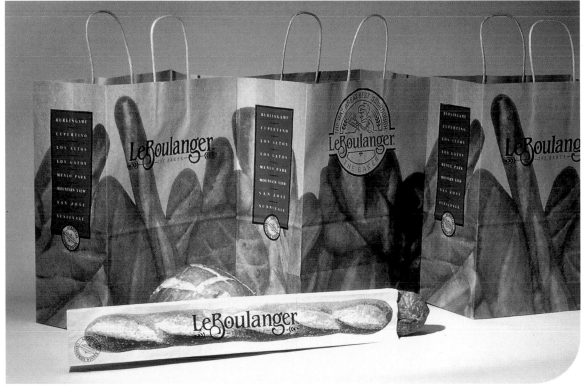

For this group of twenty family-owned bakeries, the designers suggested giving each bag its own character. They incorporated a logotype, an emblem, and various photographs to identify Le Boulanger as an award-winning sourdough bakery where each location's family makes fresh bread daily. Since the elements are used in different ways, the bags retain a look that avoids saying "franchise."

Brown kraft paper and a tribal logo reinforce the feeling of capturing the fragrant java elixir at its source.

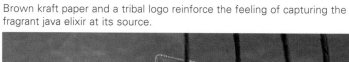

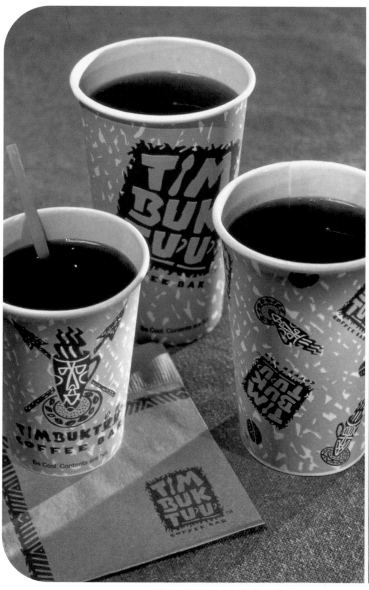

Client Timbuktuu Coffee Bar
Design Firm Sayles Graphic Design
Art Director/Designer/Illustrator John Sayles

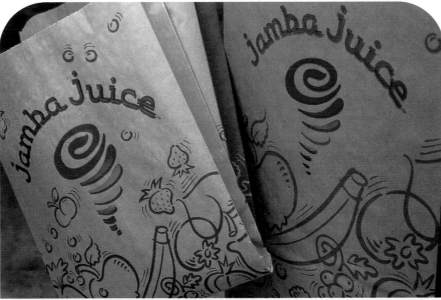

Client
Jamba Juice
Design Firm
Hornall Anderson Design
Works, Inc.
Art Director
Jack Anderson
Designers
Jack Anderson, Lisa Cerveny,
and Suzanne Haddon
Illustrator
Mits Katayama
Manufacturer
Zenith Paper Products Corp.
Paper/Printing
Kraft paper stock; flexo
printing process

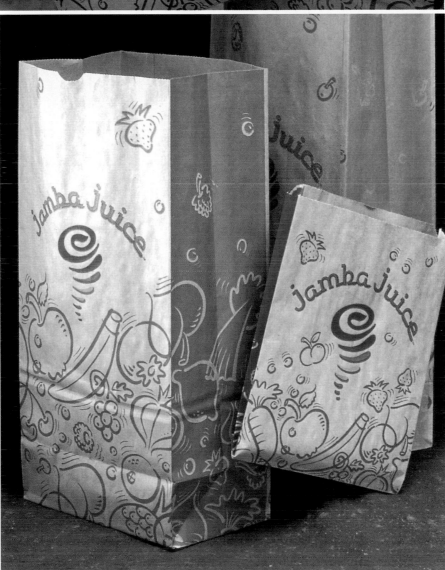

The designers aimed
to develop an overall brand
identity and trade dress that
would communicate that
Jamba Juice is the authority
on juice and nutrition.

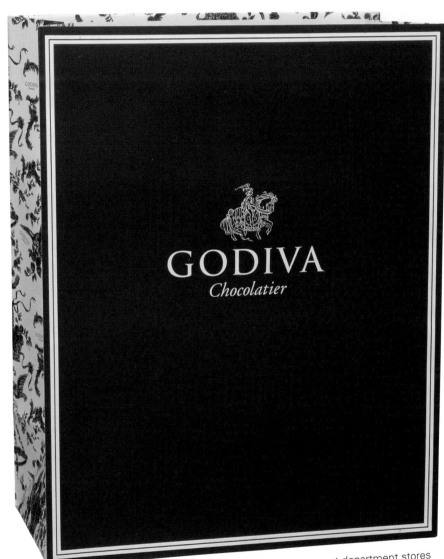

The display bag was fashioned and sold for in-house use at department stores to ensure further brand identity. The toile de Jouy print conveys femininity and old-world decadence.

Client Godiva
Art Director Steven Maisec
Distributor Commonwealth Packaging
Manufacturer Keenpac North America Limited

The sprig of foliage hints at the natural food products that are inside.

Client
Il Bucchero
Design Firm
Tangram Strategic Design
**Art Director/
Designer/Illustrator**
Antonella Trevisan
Manufacturer
Asticarta
Paper/Printing
Recycled paper; rotoffset7

The packaging for the gourmet popcorn company suggests overflowing abundance.

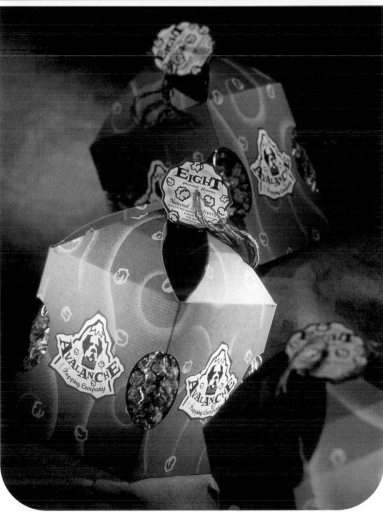

Client
Avalanche Popping Company
Design Firm
Gardner Design
Art Director
Bill Gardner
Designer
Brian Miller

Client Storz
Design Firm revoLUZion
Art Director/Designer/Illustrator Bernd Luz

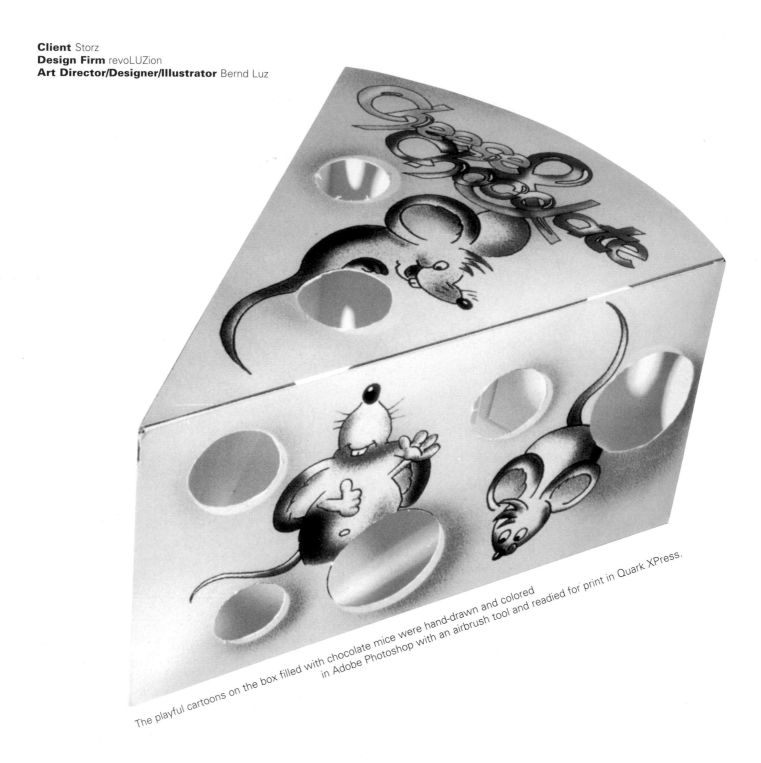

The playful cartoons on the box filled with chocolate mice were hand-drawn and colored in Adobe Photoshop with an airbrush tool and readied for print in Quark XPress.

Utilizing Illustrator 6.0 to fashion the piece, the designers chose a non-traditional color to distinguish the product from its competition. The client, a producer of bananas and shrimp food, is from Ecuador.

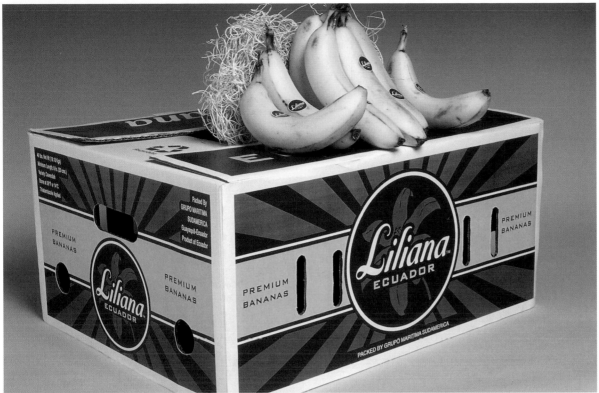

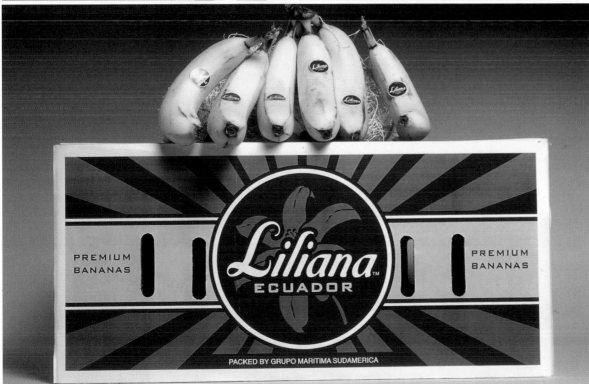

Client
Grupo Maritima
Design Firm
TDC/The Design Company
Art Director
Richard Owens
Designers
Mark Otero and Eric Pino
Illustrators
Mark Otero and Sean Flanagan
Manufacturer
Grupo Maritima
Paper/Printing
Flexography; cardboard

Continuing with its "Art
of Refreshment" campaign,
this series targets a younger
audience with graphics that
are thematically linked to the
brand and flavor.

Client Coca-Cola Company
Design Firm Lipson-Alport-Glass & Associates
Art Director Howard Alport

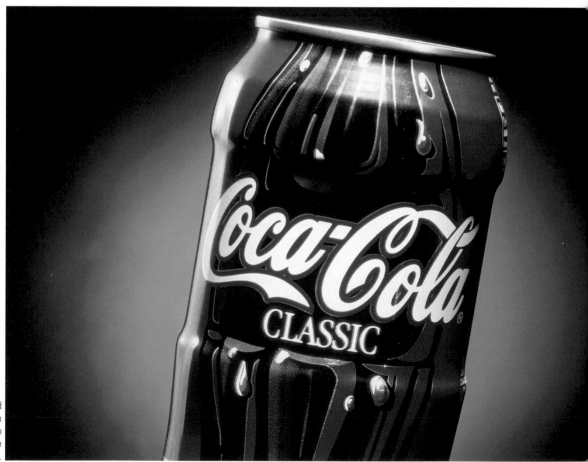

The Coca-Cola Company introduced
the new contour in 1996; the design
firm wanted the label graphics to
support the contour and continue
the integrity of the original design.

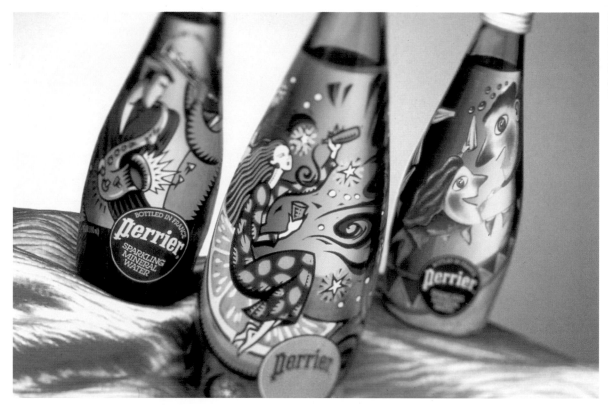

Client
Perrier
Design Firm
Lipson-Alport-Glass
& Associates
Art Director
Howard Alport

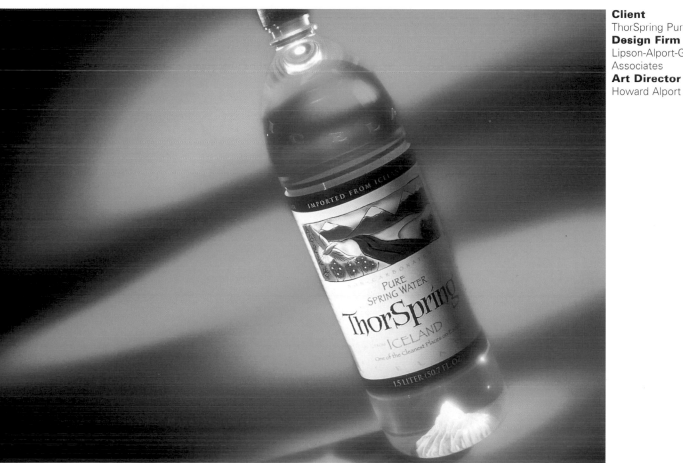

Client
ThorSpring Pure Spring Water
Design Firm
Lipson-Alport-Glass &
Associates
Art Director
Howard Alport

Along with the colorful illustration on the label that salutes the brand's Icelandic heritage, the new bottle's base displays a detail that resembles a mountain; when the bottle is filled with water, this image is magnified.

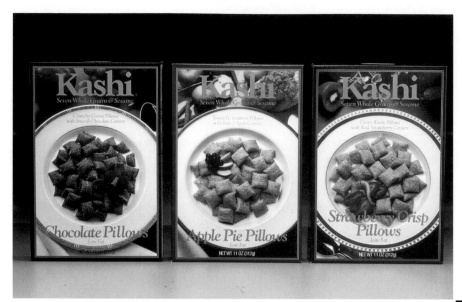

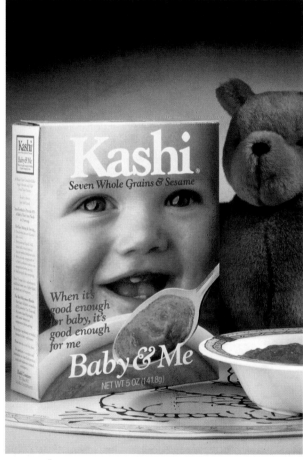

Client Kashi
Design Firm Mark Oliver, Inc.
Manufacturer Kashi Co.
Printing Mainove Inc.

The use of close, tightly cropped images makes for bold and energetic packaging
that gives the impression that real people endorse the products.

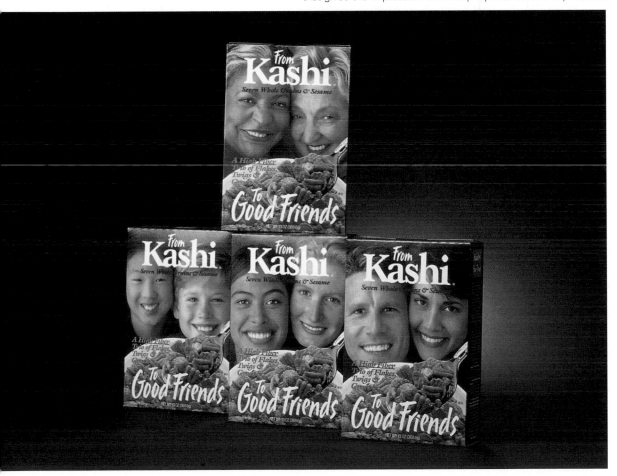

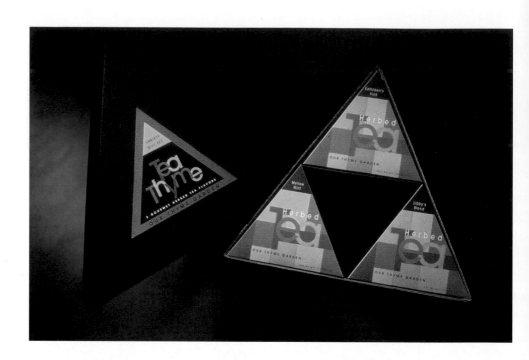

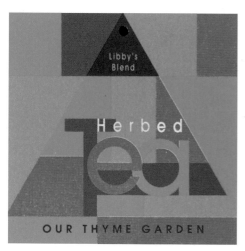
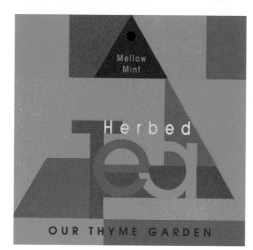
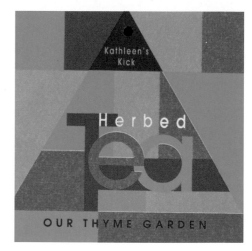

Client Our Thyme Garden
Design Firm Lambert Design
Designer Christie Lambert Rasmussen
Distributor Our Thyme Garden
Printing McCord Printing Co.
Paper Mohawk Tomahawk

The hangtags for herbed teas and biscotti possess a mighty graphic presence maintained within a small amount of space.

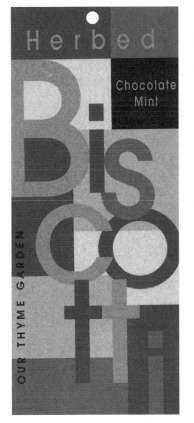

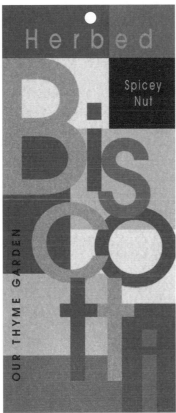

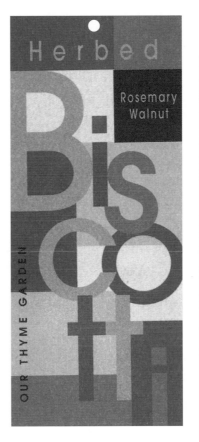

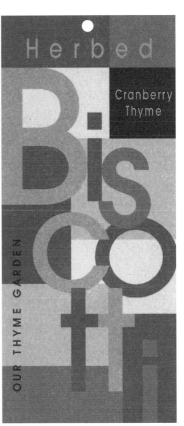

The crisp, clean design of the bottle and label evokes cool, refined refreshment. A combination of transparency, updated typography, and matte silver helps update the look.

The product was developed as an entry into the "Generation X" shooter and Schnapps market. Humorous illustrations create a sense of play while strong logotype allows secondary branding.

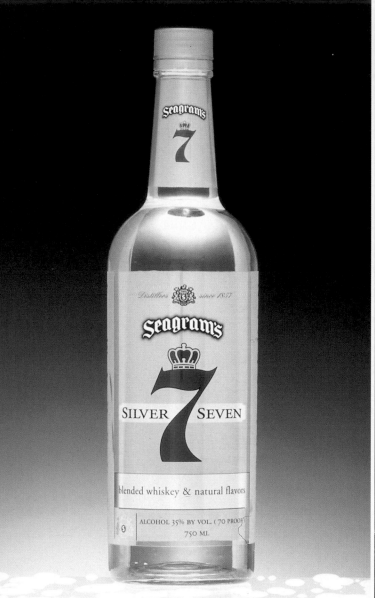

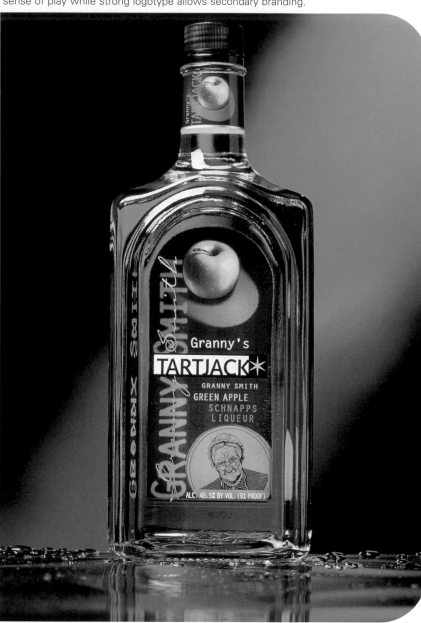

Client Seagram's Silver Seven
Design Firm Port Miolla Associates
Art Director Rob Swan

Client Seagram's Granny's Tartjack
Design Firm Port Miolla Associates
Art Director Rob Swan

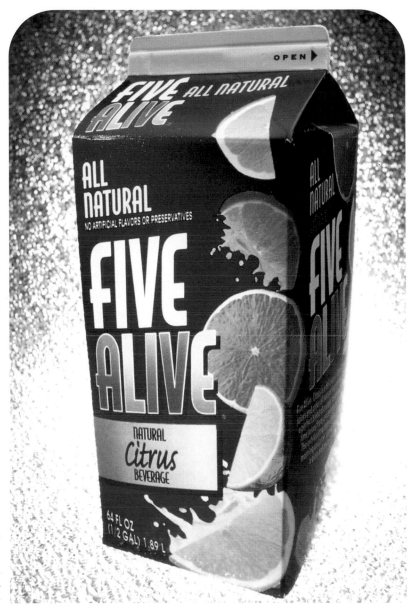

Client
Five Alive
Design Firm
Hillis Mackey & Company
Creative Director/Designer
Terry Mackey

The previous design had been on the market for about fifteen years, and the client wished to reenergize it and make the product more tantalizing.

Client Wheaties
Design Firm Hillis Mackey
Creative Director/Designer Terry Mackey

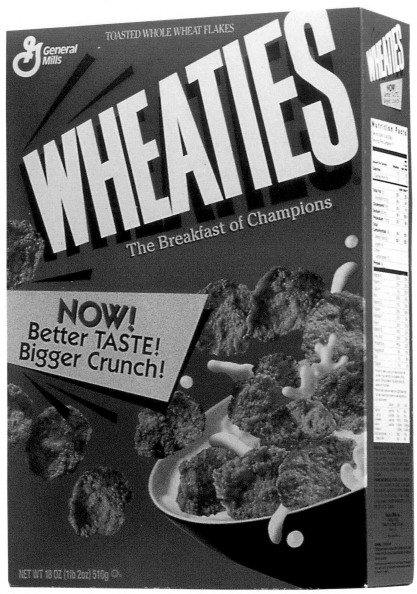

The client wanted to add more excitement and movement
to the box to target a younger audience.

Client Drakes
Design Firm Berni Design
Art Director Mark Eckstein
Distributor Drake Bakeries, Inc.

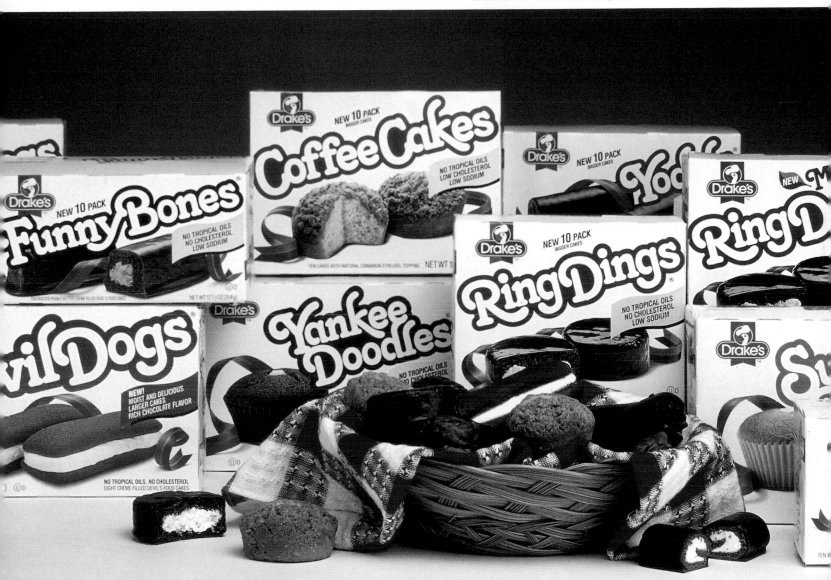

The classic, familiar bubble text and tasty imagery are typical of this genre of snack foods.

Stick-on labels applied to stock bags are a creative, affordable alternative in package design.

The natural kraft paper and freehand illustration set these goods apart from similar products on the market.

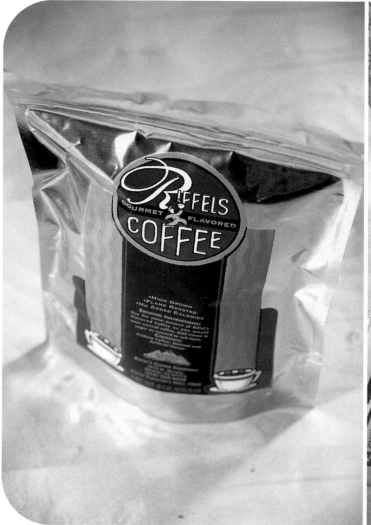

Client
Riffels Coffee
Design Firm
Love Packaging Group
Art Director/Designer/Illustrator
Tracy Holdeman
Paper/Printing
Moore Labels

Client
Twin Valley Popcorn
Design Firm
Love Packaging Group
Art Director/Designer/Illustrator
Tracy Holdeman
Paper/Printing
Towanda Printing

The name, graphics, and color scheme were chosen to convey a fun, appropriate image that reflects the feel of the Southwest.

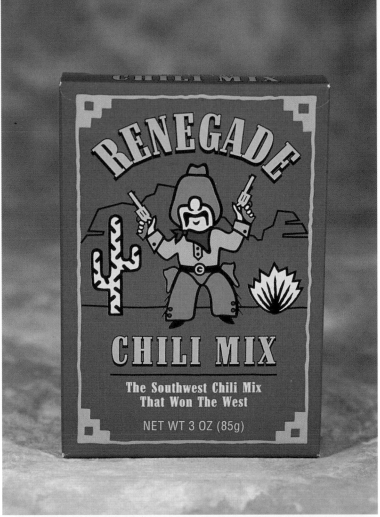

Client Renegade Chili Mix
Design Firm Bullet Communications
Creative Director/
Designer/Illustrator Tim Scott

The popcorn container was developed to address the increasing interest in the Kwanzaa holiday. The tin's graphics display the elements of the week-long celebration.

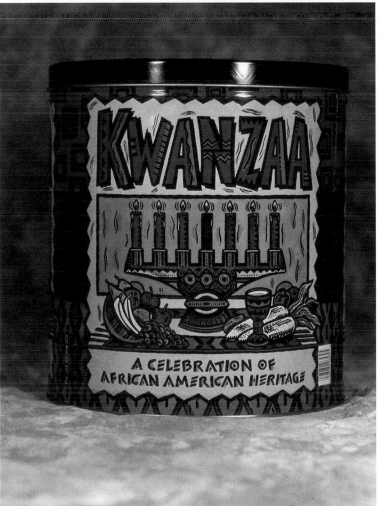

Client Bullet Communications
Design Firm Bullet Communications
Creative Director/Designer Tim Scott
Illustrator Patti Green

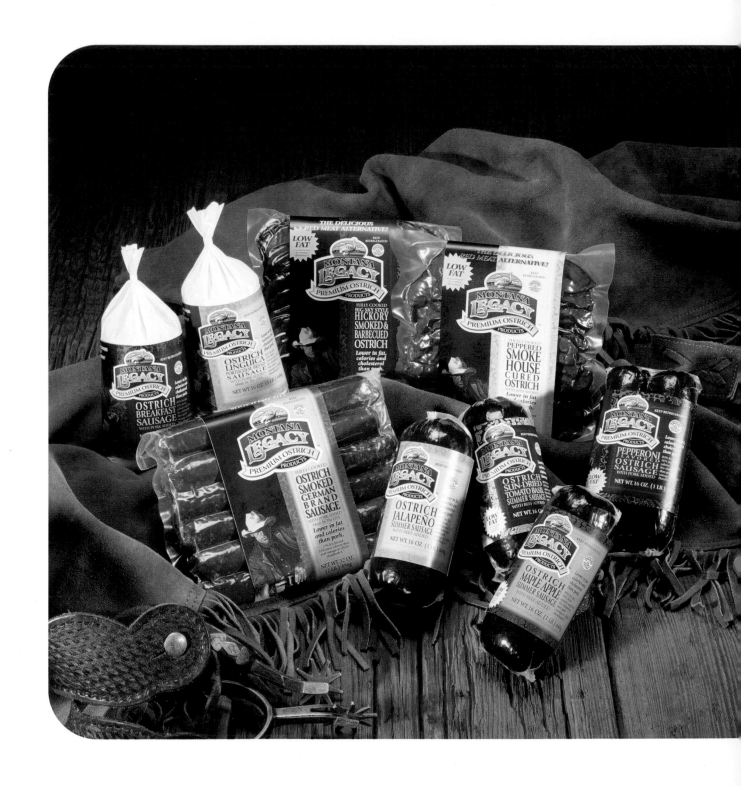

Client Montana Legacy Premium Ostrich Products
Design Firm Heins Creative
Creative Director/Designer Joe Heins

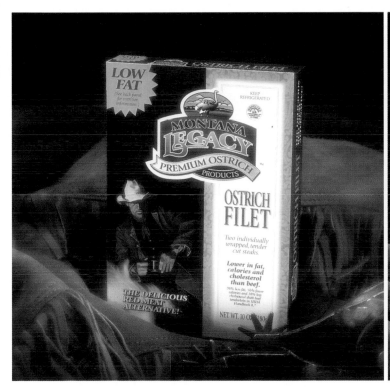

In an attempt to make consumers comfortable with the idea of eating meat from an animal that most people consider a zoo attraction, the designer created an image that is both familiar and attractive based on the mystique of the American West.

Client L'Opera
Art Director Jeff Gasper
Design On the Edge Design
Distributor PSPCO
Manufacturer Bonita Pioneer Packaging

Client The Egg & I Restaurant
Distributor Greenebaum Brothers
Manufacturer Greenebaum Brothers
Paper/Printing One-color printing on natural kraft paper; one-color IMF flexoprinting on laminated gable box

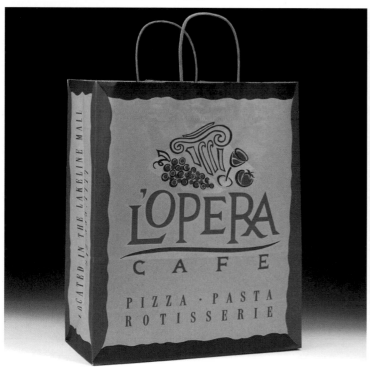

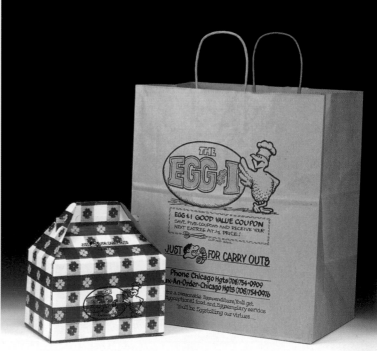

Designed for take-out Italian cuisine, it emphasizes that even food taken "to go" can be civilized.

The playful packaging reminiscent of a family picnic was designed for the restaurant's small quantities and quick turnarounds.

Client Near East
Design Firm Addis Group
Art Director Steven Addis

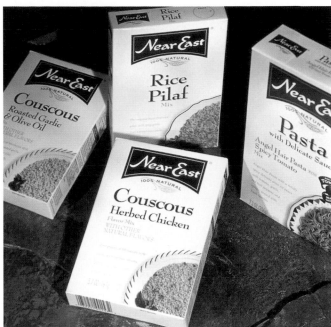

Client Jelly Belly
Design Firm Addis Group
Art Director Steven Addis

The script of the logo and the cropped picture of the dish make the product appealing without being graphically overwhelming.

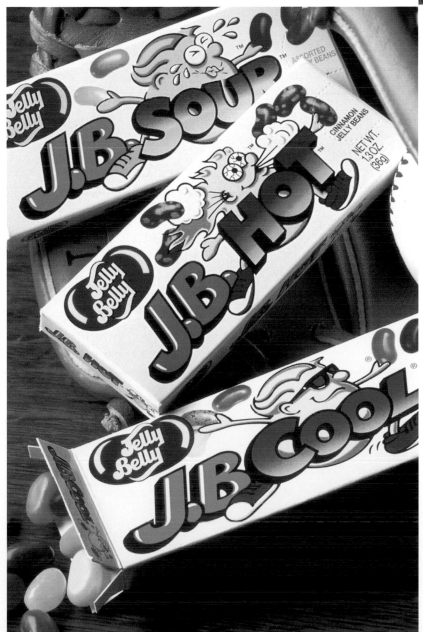

For the new line of jellybeans, the firm took the familiar brand identity and jazzed it up with an animated cartoon character.

Public Spaces

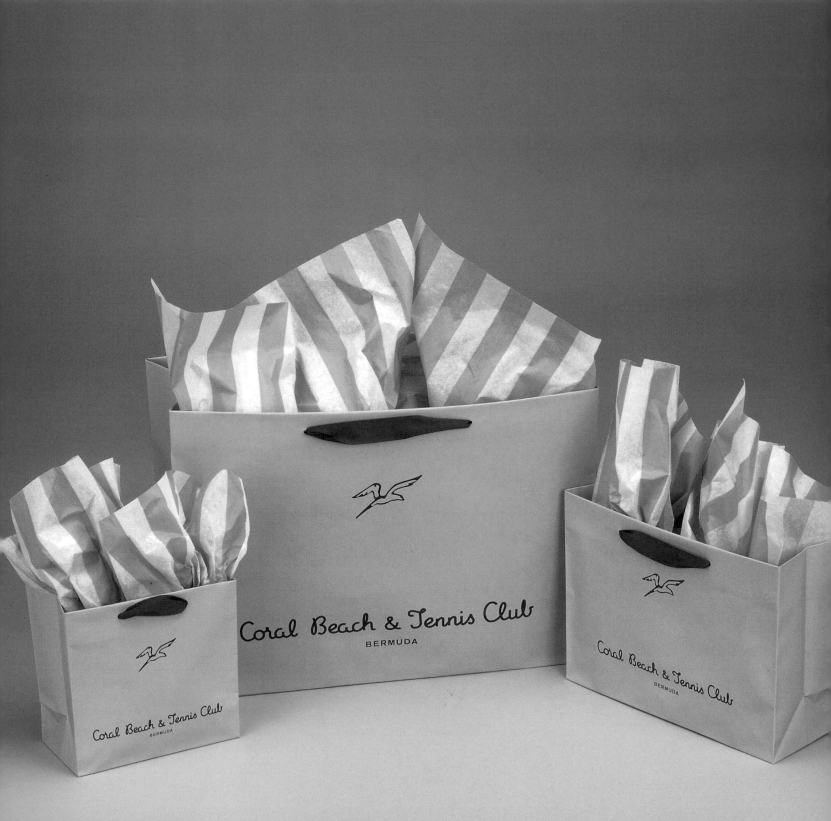

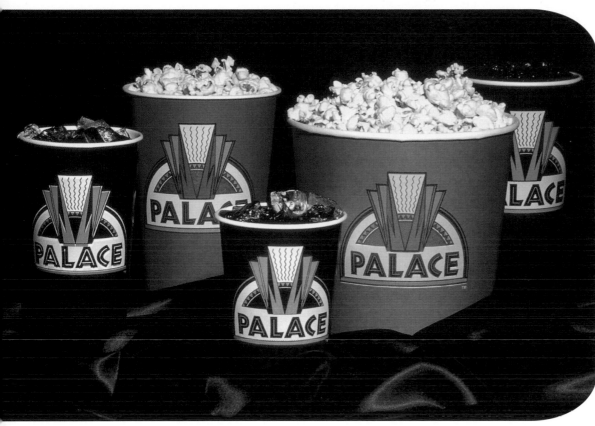

Client The Palace Theatre
Design Firm Greteman Group
Art Director Sonia Greteman
Designers Sonia Greteman
and James Strange
Paper/Printing Flexo

The design emulates the splendor of the Art Deco movie theater.

Client Coral Beach & Tennis Club
Manufacturer Keenpac North America Limited

The soft pastel color, loose script, and airy
design transmit the idea of a relaxed beach
environment, which is furthered by the blue,
a reminder of the ocean.

Client
Philadelphia Museum of Art
Design Firm
Joel Katz Design, Inc.
Art Director
Joel Katz
Distributor
The Metro Packaging Group, Inc.
Manufacturers
Interstate Packaging Corporation
(shopping bag);
Handelok Bag Company
(die-cut merchandise bags)
Paper/Printing
Oatmeal kraft; two-color
flexo with screen

Client Museum of Jewish Heritage
Design Firm Grafik Communications, Ltd.
Art Director Judy Kirpich
Designers Gretchen East and David Collins
Calligrapher Lillie Lee
Manufacturer S. Posner Sons Inc.
Paper/Printing 150 gsm; offset printing with matte lamination

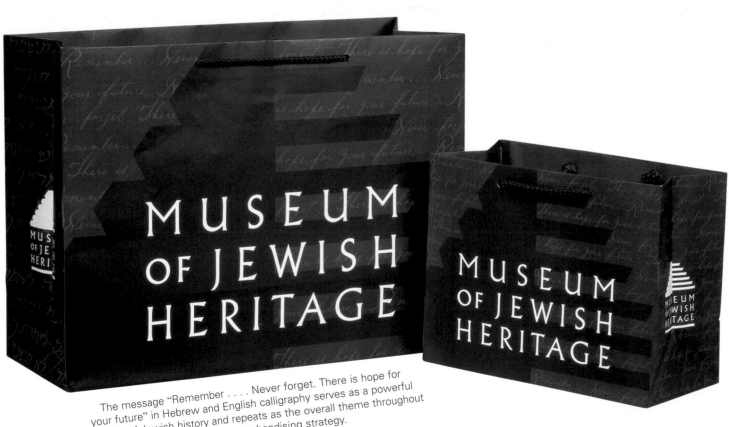

The message "Remember Never forget. There is hope for your future" in Hebrew and English calligraphy serves as a powerful reminder of Jewish history and repeats as the overall theme throughout the museum's merchandising strategy.

The same substrate was utilized for all the bags in an effort to control the variations caused by the use of two different flexo presses. The large die-cut bag was designed as a folder to house scarves and ties, while the smaller one functions as a premium card bag with a handle feature.

The shopping bag is standard, but the envelopes, designed to hold prints and postcards, are especially distinctive. A Giverny sky-blue envelope was provided as a special touch for a Monet exhibit.

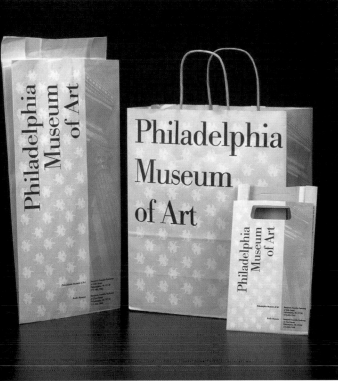

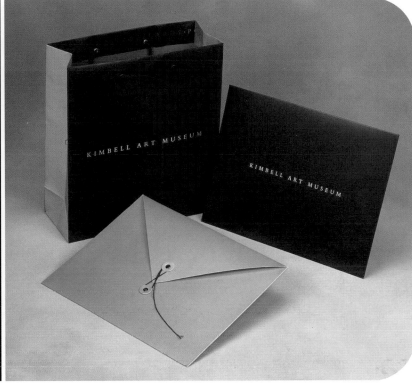

Client Kimbell Art Museum
Design Firm Tom Dawson Graphic Designs
Distributor Jayne Norwood & Co.
Manufacturer Keenpac North America Limited

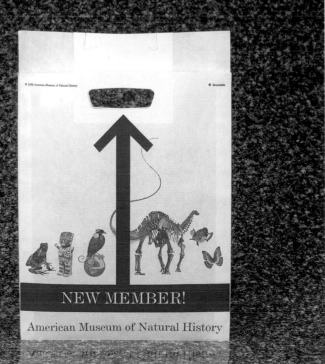

Client American Museum of Natural History
Design Firm American Museum of Natural History
Distributor Atlas Paper Co.
Manufacturer Handelok Bag Company
Paper/Printing White kraft; two-color

The bold blue arrow and images from the museum on the bag, which is designed to hold magazines and other literature, make becoming a member seem like an exciting prospect.

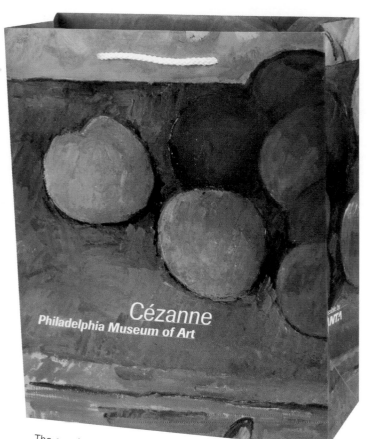

Client The Philadelphia Museum of Art
Design Firm Greenberg-Kingsley/NYC
Art Director Mark Kingsley
Designer Karen Greenberg
Distributor The Metro Packaging Group, Inc.
Manufacturer Keenpac North America Limited
Paper/Printing Coated one side litho paper;
four-color process offset

The special Cézanne exhibition gift/shopping bag features the piece "Apples and Biscuits," circa 1880, which the designer conveniently reminds the consumer on the bottom of the bag. For art lovers, the sack speaks for itself.

Client Guggenheim Museum Store
Design Firm Greenberg-Kingsley/NYC
Art Director Mark Kingsley
Designer Karen Greenberg
Distributor The Metro Packaging Group, Inc.
Manufacturer St. Clair Pakwell
Paper/Printing Claycoat four-color process; two rotogravure printing

The challenge was to produce a bag to carry postcards and small purchases that features the legendary Frank Lloyd Wright's drawing of the museum at night.

The playful illustration, reminiscent of nineteenth-century circus paintings, has an impact on the viewer without being overwhelming.

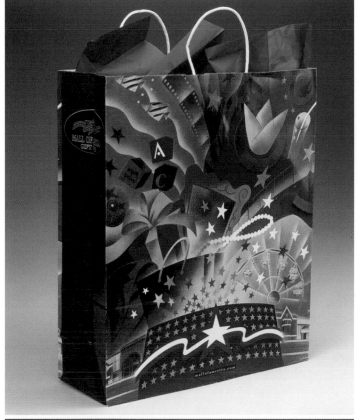

Client Mall of America
Design Firm Bardwell & Company
Art Director/Designer Colin Bardwell
Illustrator Coco Masuda
Distributor Gift Box Corporation of America
Manufacturer Interstate Packaging Corporation
Paper/Printing Claycote substrate; flexographic printing; four-color process; 1 PMS color; UV high gloss varnish; produced at 120-line screen with water-based inks

Generating an identity that separates the San Diego Zoo from the hundreds of other zoos in the United States, the bag depicts one of the most popular and well-known attractions, the giant panda bear.

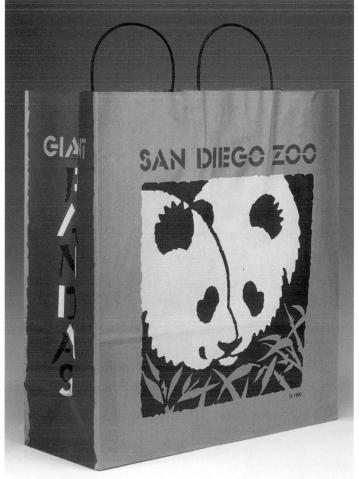

Client San Diego Zoo
Design Firm Zoological Society of San Diego Zoo
Art Director/Designer/Illustrator Tim Reamer
Distributor Germain Packaging
Manufacturer Interstate Packaging Corporation
Paper/Printing Natural kraft substrate; flexographic printing; line art; four colors with water-based inks

Client La Salle Union Station
Design Firm Grafik Communications, Ltd.
Designers Mary Wagner and Judy Kirpich
Illustrator Taran 2
Manufacturer S. Posner Sons Inc.

Client LaSalle Partners 2000 Penn
Design Firm Grafik Communications, Ltd.
Designers Gregg Glaviano, Mary Wagner, and Judy Kirpich
Illustrator Diane Bigda
Manufacturer S. Posner Sons Inc.
Paper/Printing Matte paper; four-color process

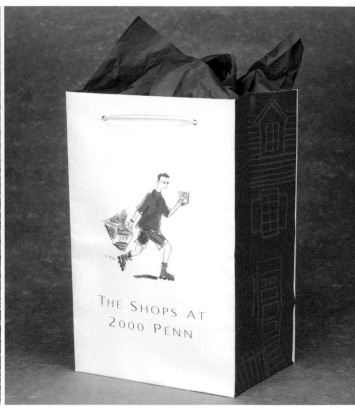

Four architectural images on the shopping bag convey the grandeur of Union Station, located in our nation's capital.

Designed for a conglomerate of shops in Washington, D.C., the bag illustrates that there is something for everyone at 2000 Penn, from the sophisticate to the hipster.

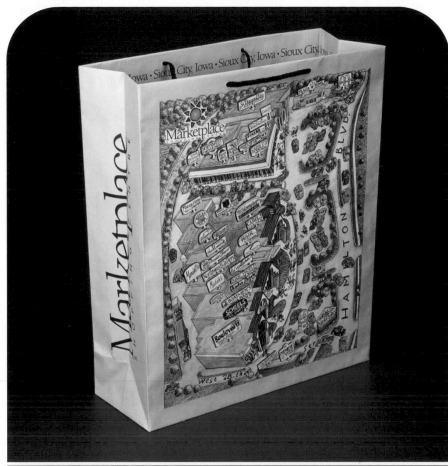

The problem of lost kids has been eliminated at this shopping center; although busy, the map is fun and useful.

Client Marketplace
Distributor Gift Box Corporation of America
Manufacturer/Paper/Printing Keenpac North America Limited

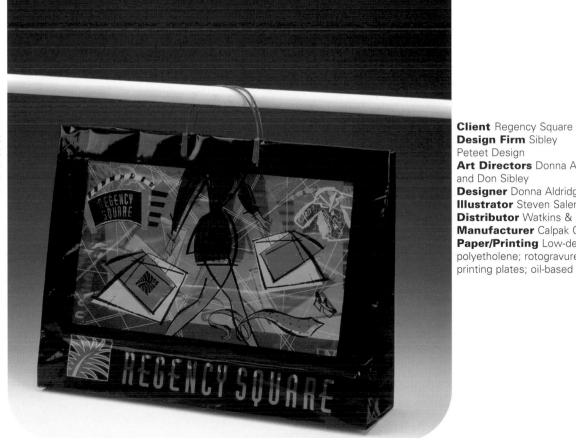

The goal was to make a stunning bag that would hold up against the frequent Florida rains and a good yank from a shoplifter.

Client Regency Square
Design Firm Sibley Peteet Design
Art Directors Donna Aldridge and Don Sibley
Designer Donna Aldridge
Illustrator Steven Salerno
Distributor Watkins & Co.
Manufacturer Calpak Corp.
Paper/Printing Low-density polyetholene; rotogravure printing plates; oil-based inks

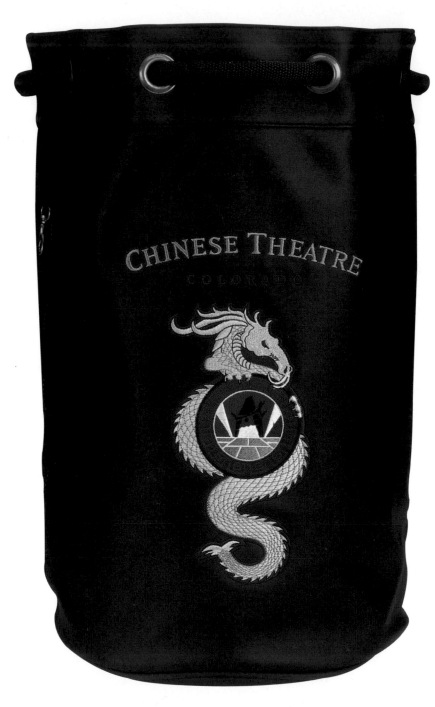

Client Mann Theatres/
Chinese Theatre Store
Design Firm Smullen
Design, Inc.
Art Director/Illustrator
Maureen Smullen
Designers Amy Hirschman
and Maureen Smullen
Distributor Commonwealth
Packaging
Manufacturer Keenpac
North America Limited

Part of a new brand identity for the Chinese Theatre Store in
Colorado, the sturdy bag will bring about contemporary recognition
of an historical landmark.

The travel-ready satchel functions as a promotional piece for a local airport authority.

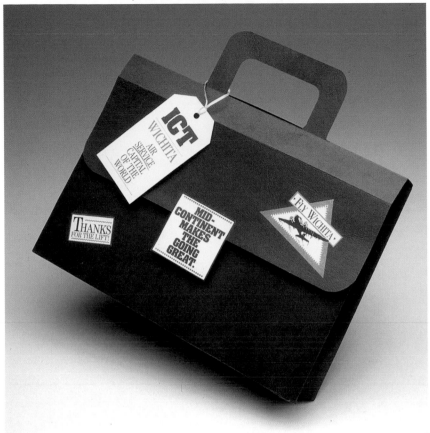

Client Wichita Chamber
of Commerce
Design Firm Gardner Design
Art Director Bill Gardner
Designer James Strange

The design and color elements communicate an upscale image for the complex and enhance its reputation as a quality shopping center.

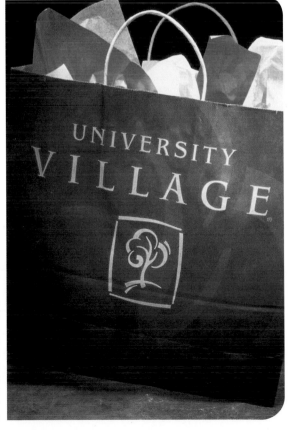

Client University Village
Design Firm Hornall Anderson
Design Works, Inc.
Art Director Jack Anderson
Designers Jack Anderson and
Cliff Chung
Illustrator David Bates
Distributor Unisource
Paper/Printing Kraft paper
stock; flexo printing process

Client Cooper-Hewitt,
National Design Museum,
Smithsonian Institution
Design Firm
Memo Productions, Inc.
Art Director
Douglas Riccardi
Designer
Kate Johnson
Manufacturer
Atlas Paper Co.
Photographer
Matt Flynn

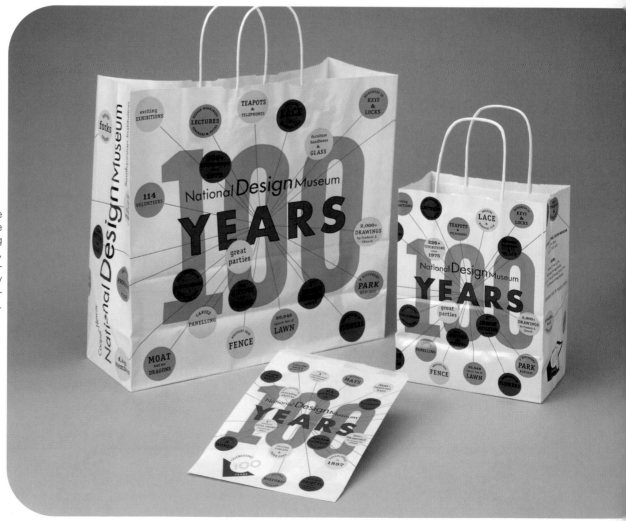

The bag features a multitude of reasons to celebrate the institution's centennial. Using three colors to generate four, the designers created a playful and informative identity program for America's definitive design museum.

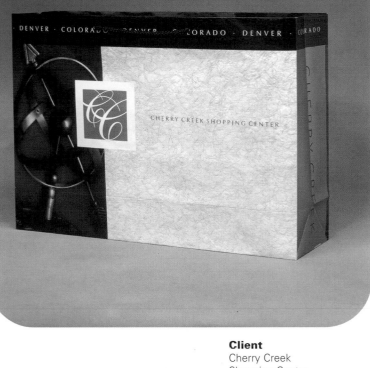

The designer wanted to suggest a cultured elegance in keeping with the shopping center's fine reputation.

Client
Iowa State Fair
Design Firm
Sayles Graphic Design
Art Director/Designer/Illustrator
John Sayles

Client
Cherry Creek
Shopping Center
Design Firm
Karsh & Hagan
Communications, Inc.
Art Director/Designer
Troy Farrow
Manufacturer
Modern Arts Packaging

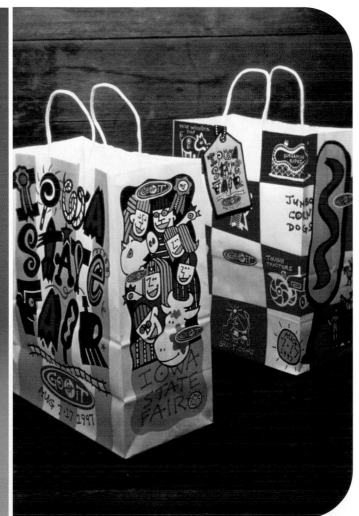

The words "Iowa State Fair" are formed with items familiar to fair-goers: giant lollipops, midway rides, people, and of course, corndogs.

Client Tirol Galleria
Design Firm 2M&G
Art Directors Meg Goodman and Gil Wright
Designers Dev Murata and Suzy Borlin
Distributor Watkins & Co., Inc.
Manufacturer/Paper/Printing Keenpac North America Limited
Photographer Geoff Nilsen

Client La Costa
Designer Jim Parker
Distributor Germain
Manufacturer Bonita Pioneer Packaging

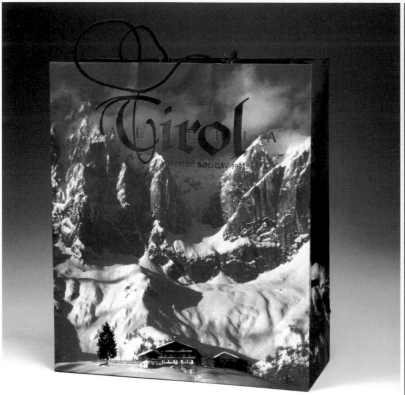

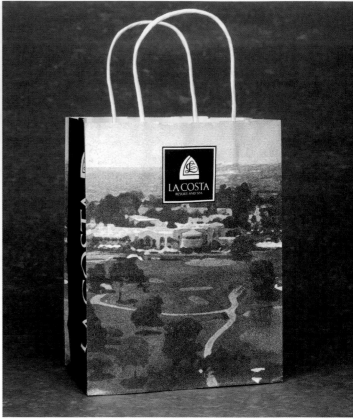

The fairy book script and Alpine scene coupled with the red-and-white lettering are the perfect complement to the "Austrian Holiday" theme.

The one-color sepia photograph summons a sense of the historic value of the resort and spa.

Client The National Trust Japan Store/Hankyu Department Store Co., Ltd.
Design Firm Package Land Co. Ltd.
Art Director/Designer Yasuo Tanaka
Distributor/Manufacturer The Pack Co., Ltd.

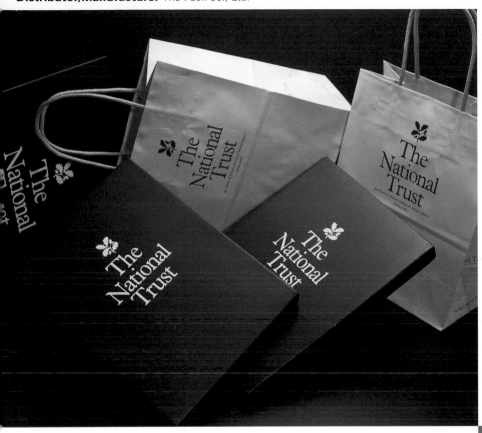

The uncomplicated serif lettering and no-nonsense design demand respect for the store.

The choice of colors and silhouette of a pagoda evoke the vibrant Chinese culture and make for a graphically striking bag.

Client
Chinese Theatre
Designer
Smullen Design
Distributor
Commonwealth Packaging
Manufacturer
Bonita Pioneer Packaging

Gifts&Holiday

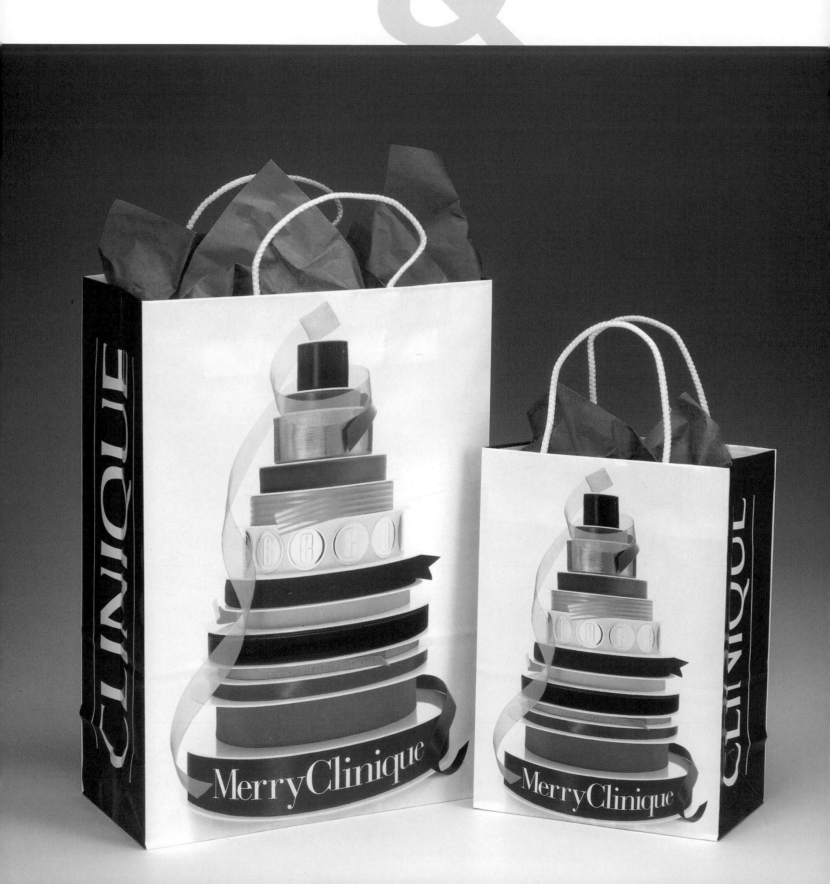

Client
Package Land Co. Ltd.
Design Firm
Package Land Co. Ltd.
Art Director/Designer
Yasuo Tanaka

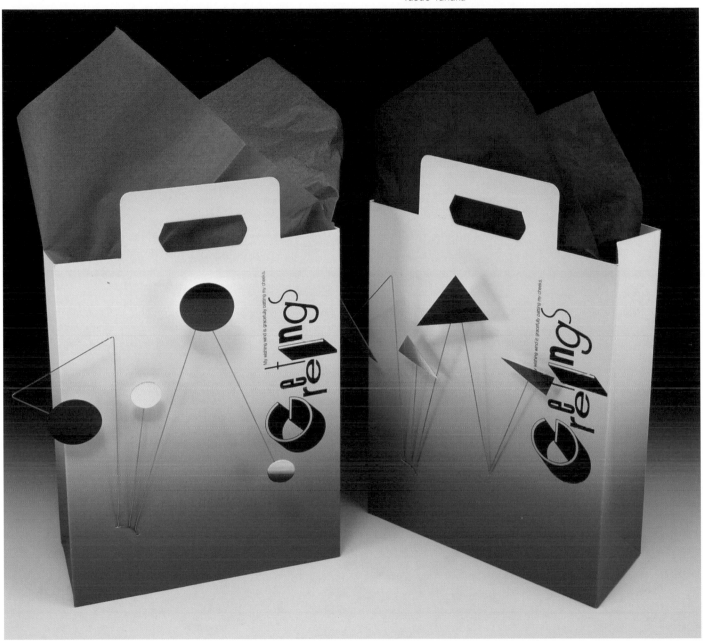

The mobile-like design on the front of the bag
is an unusually clever accent.

Client
Clinique/Estée Lauder
Design Firm
Clinique In-house
Manufacturer
Modern Arts Packaging

The clever graphic features gift ribbons stacked up to look like a Christmas tree and provides a fresh perspective
by avoiding the typical holiday colors. The bag is perfectly suited to hold seasonal in-store promotional items.

The lively hearts seem to jump out from the stark background on the glossy laminated paper.

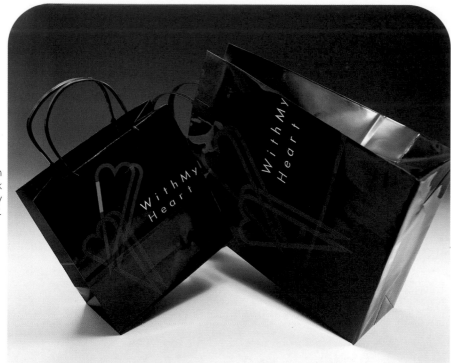

Client With My Heart/Matsushiro Co., Ltd.
Design Firm Package Land Co. Ltd.
Art Director/Designer Yasuo Tanaka

Although intended as a generic gift box for stores and boutiques, the piece can, by no means, be labeled as plain.

Client Package Land Co. Ltd.
Design Firm Package Land Co. Ltd.
Art Director/Designer Yasuo Tanaka

The client's customary logo appears on the bag after being given a seasonal twist.

Client Tobu
Design Firm Carré Noir
Art Director/Designer/
Illustrator Piotr

The designer reduced several cultural icons to their most memorable facial features and accessories for the bags.

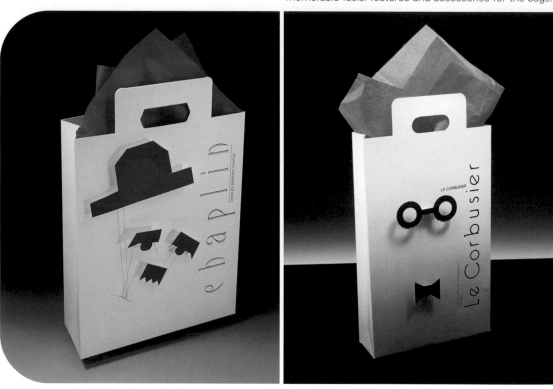

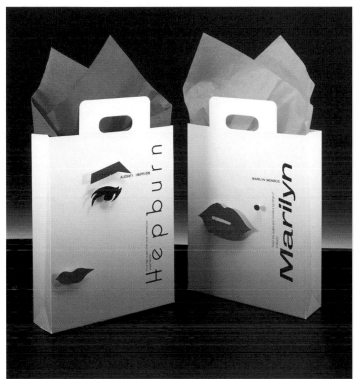

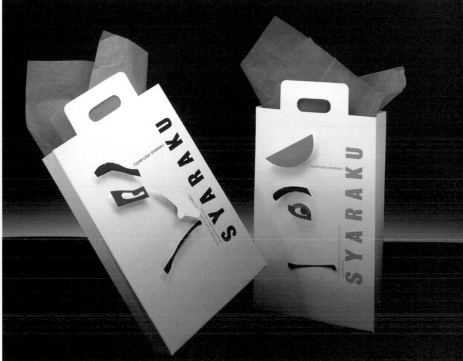

Client Package Land Co. Ltd.
Design Firm Package Land Co. Ltd.
Art Director/Designer Yasuo Tanaka

Client Big Dog Sportswear
Design Firm Big Dog Sportswear
Art Director/Designer/Illustrator Rick Garcia
Distributor Commonwealth Packaging
Manufacturer Interstate Packaging Corporation
Paper/Printing Claycote substrate; flexographic printing; four-color process; one PMS color; gloss varnish; produced at 120-line screen with water-based inks

Client Package Land Co. Ltd.
Design Firm Package Land Co. Ltd.
Art Director/Designer Yasuo Tanaka

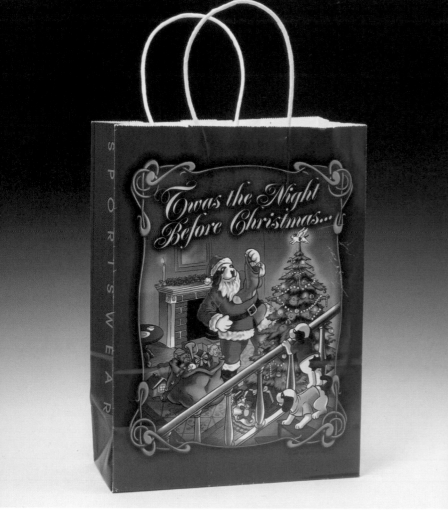

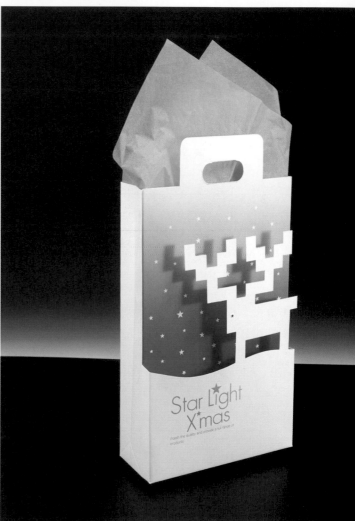

The Big Dog Christmas bag presents a witty, canine take on one of the most exciting nights of the year.

The three-dimensional design on the gift bag, intended for the holidays, is fresh and playful.

Design Firm Linda DeVito Soltis

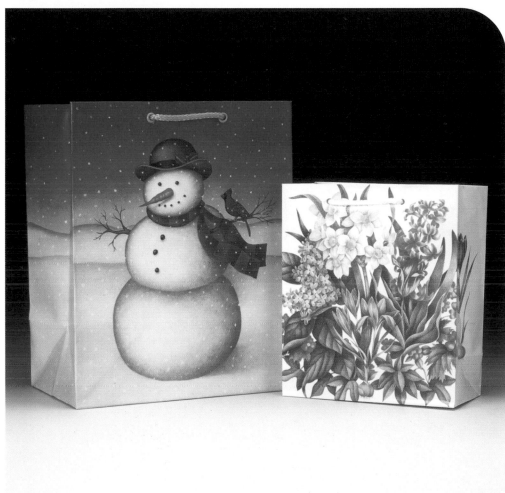

Reminiscent of childhood and hot chocolate, the bag for the Christmas holidays is sweet and endearing.

With its daffodils, hyacinth, and other flowers, the bag is appropriately called "Spring Floral."

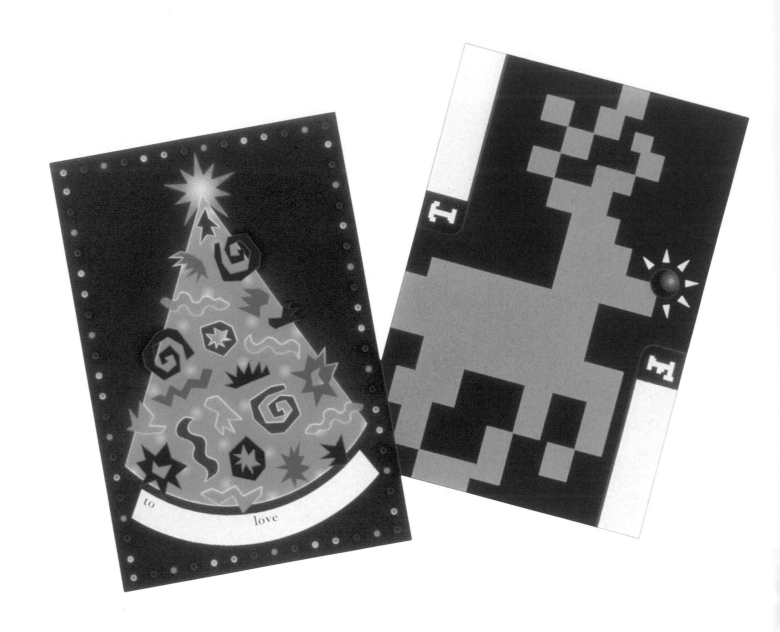

Client Lambert Design
Design Firm Lambert Design
Art Director Christie Lambert Rasmussen
Illustrator Joy Cathey

The gift tags were thoughtfully sent to clients to place on holiday packages.

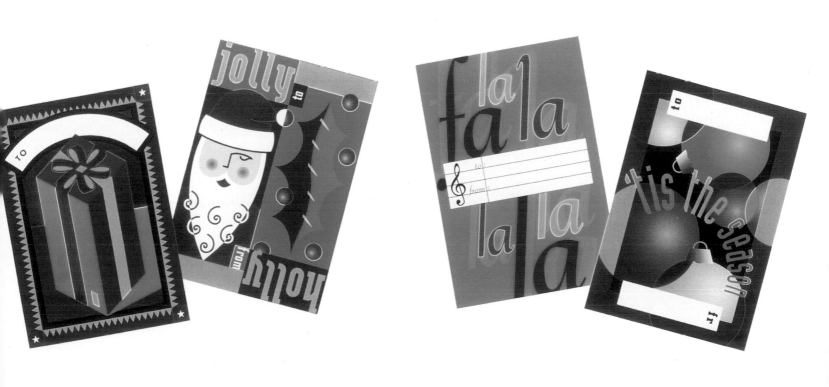

The beautifully festive bag covered with Victorian images has the potential to put even grumpy Christmas shoppers in a holiday mood.

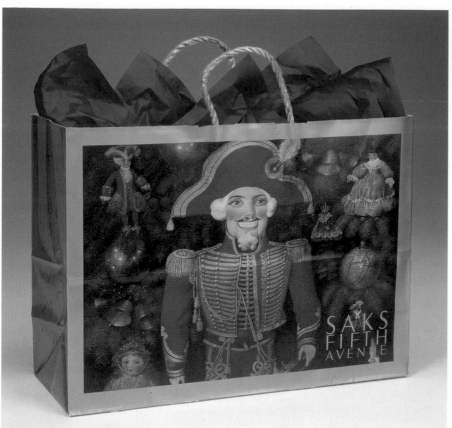

Client
Saks Fifth Avenue/Holiday
Distributor
Duro Bag
Manufacturing Company
Paper/Printing
Gravure printing with UV coating; gold, poly, three-ply twist handle.

The uncomplicated bag is elegantly symbolic of the holidays without being cliché.

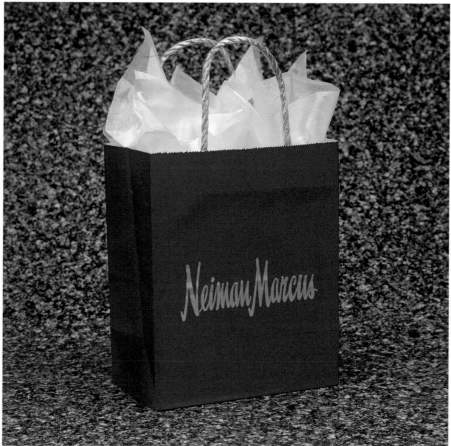

Client
Neiman Marcus Christmas
Distributor
Duro Bag
Manufacturing Company
Paper/Printing
Laminated; serrated top; gold, three-ply twist handle

The traditional Christmas colors on the well-known clothing store's bag tell the tale of a classic holiday.

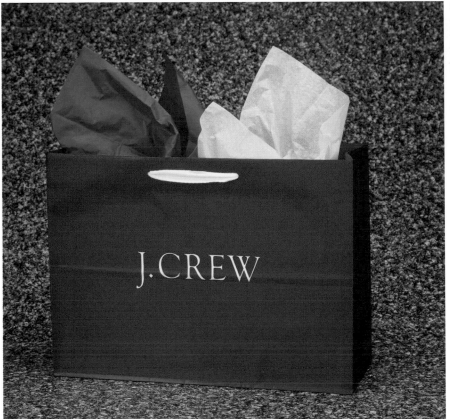

Client
J. Crew
Distributor
Duro Bag
Manufacturing Company
Paper/Printing
Kraft paper; 100% red; reversed "J. Crew" with cotton twist handle

The colorful diamond pattern hints at the exuberant decorations one can find in the *magasin des fêtes* or "party store."

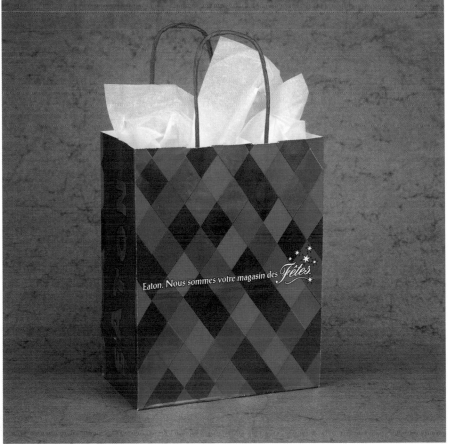

Client
The T. Eaton Co. Ltd.
Design Firm
Robert Young Associates Inc.
Art Director
Robert Young
Designer/Illustrator
Guy Bonhomme
Manufacturer
Interstate Packaging
Corporation
Paper/Printing Claycote substrate; UV high gloss varnish; flexographic printing; four-color process; one PMS color; produced at 133-line screen with water-based inks

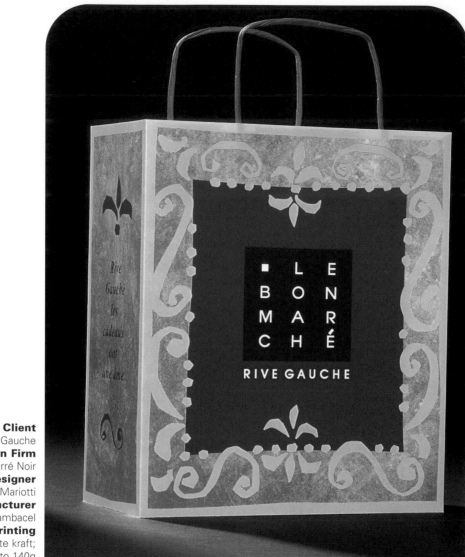

Client
Le Bon Marché Rive Gauche
Design Firm
Carré Noir
Art Director/Designer
Béatrice Mariotti
Manufacturer
Lambacel
Paper/Printing
Varnished white kraft;
weights from 110g to 140g

The shopping bags created to carry Christmas and New Year's purchases feature celebratory yuletide graphics but keep the company logo clearly at the center.

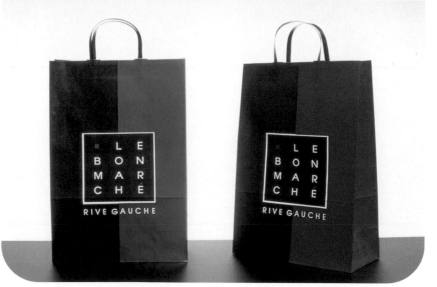

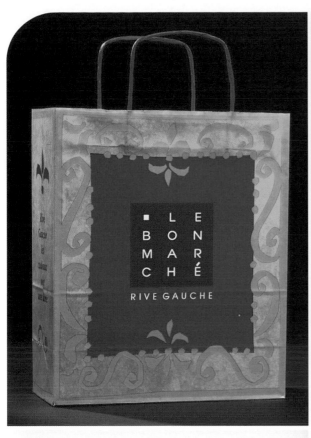

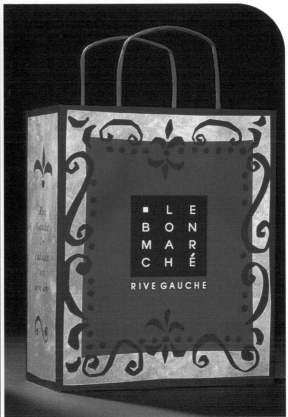

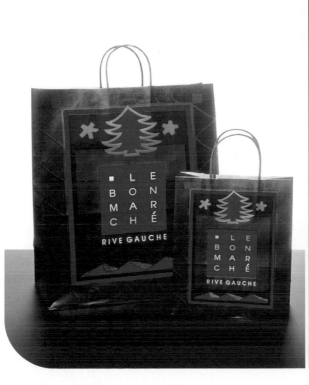

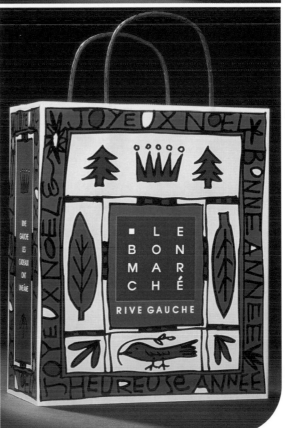

A rendition of an art piece from Ghirardelli's 100-year old archives was the main focus of the bag. Using Adobe Photoshop and elements of a love letter, the designer was able to instill a romantic, contemporary beauty into the bag.

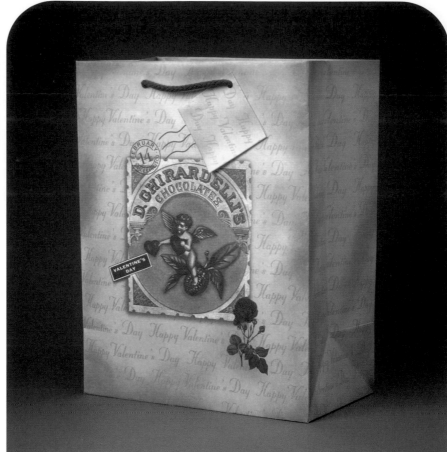

Client
Ghirardelli Chocolate Company
Design Firm
Gina Amador Design
Art Director/Designer
Gina Amador
Distributor
Northbay Paper & Packaging Co., Inc.
Manufacturer
Keenpac North America Limited

The line-art drawings for the Hallmark "Earthtone" bags are fittingly printed on recycled paper.

Client
Hallmark Cards, Inc.
Design Firm
Hallmark Cards, Inc.
Art Director
Lee Ernst
Designer/Illustrator
Mark Lineback
Manufacturer
Interstate Packaging Corporation
Paper/Printing
Natural kraft substrate; flexographic printing; three colors; produced at 85-line screen with water-based inks

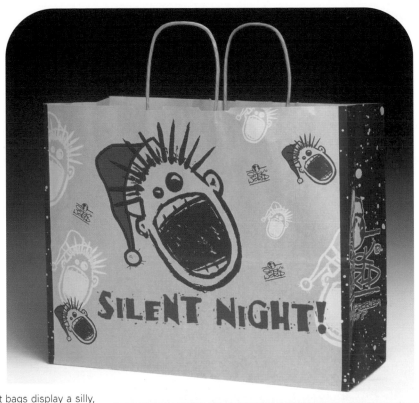

The gift bags display a silly, unconventional approach to Christmas.

Client Stickworld
Designer Stickworld
Distributor Ingram/Resource Net
Manufacturer Bonita Pioneer Packaging

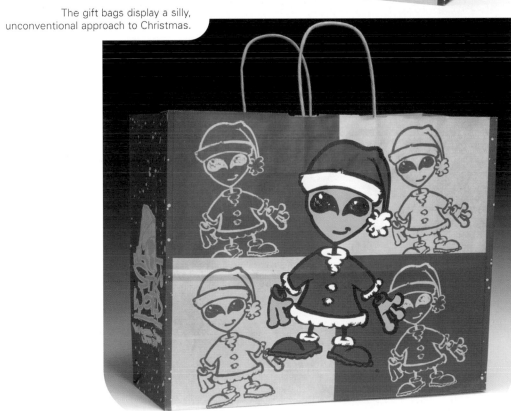

Shaped like animals and cacti, the elaborate gift boxes recall the American Southwest.

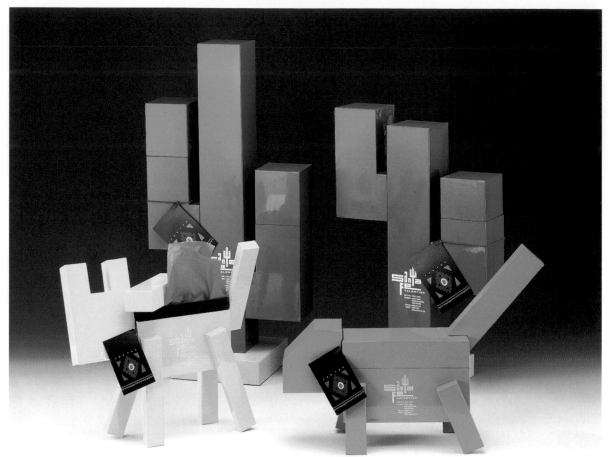

Client Package Land Co. Ltd.
Design Firm Package Land Co. Ltd.
Art Director/Designer Yasuo Tanaka

Client Package Land Co. Ltd.
Design Firm Package Land Co. Ltd.
Art Director/Designer Yasuo Tanaka

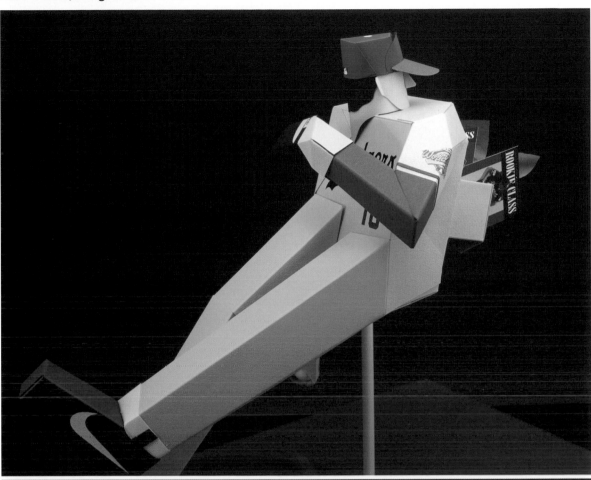

The elaborate gift box shaped as a baseball player exhibits the Japanese love for America's favorite pastime.

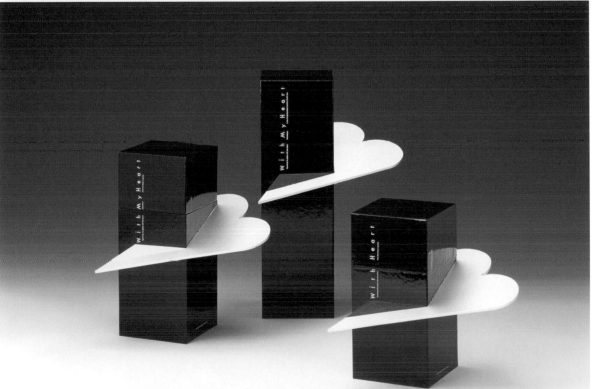

Like the other packaging from the same design firm, the box is the only giftwrap needed.

Corporate

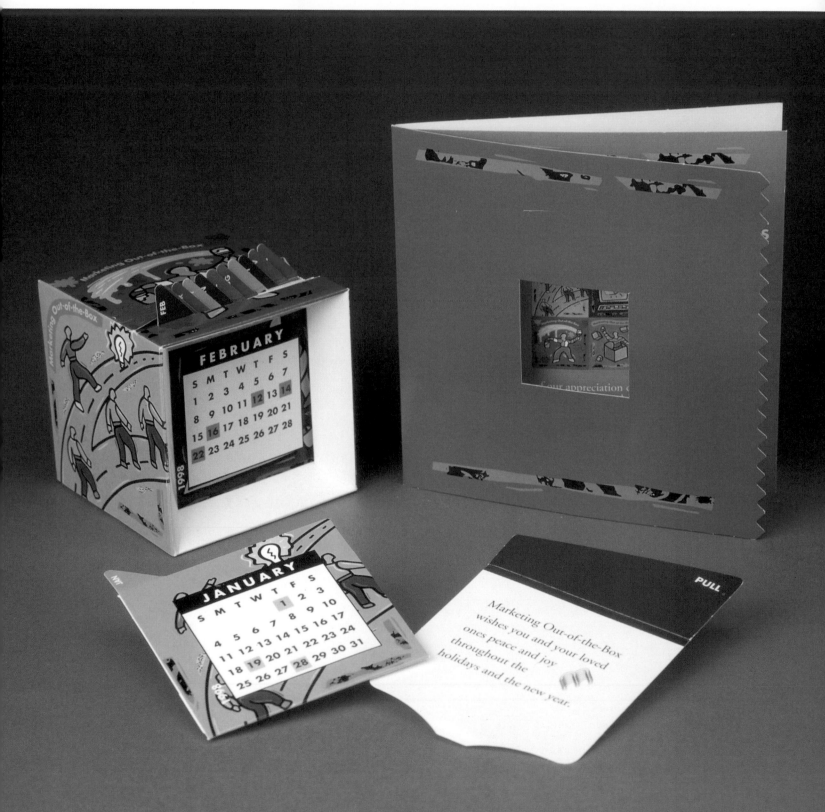

FEBRUARY

S M T W T F S
1 2 3 4 5 6 7
8 9 10 11 12 13 14
15 16 17 18 19 20 21
22 23 24 25 26 27 28

JANUARY

S M T W T F S
1 2 3
4 5 6 7 8 9 10
11 12 13 14 15 16 17
18 19 20 21 22 23 24
25 26 27 28 29 30 31

Marketing Out-of-the-Box
wishes you and your loved
ones peace and joy
throughout the
holidays and the new year.

PULL

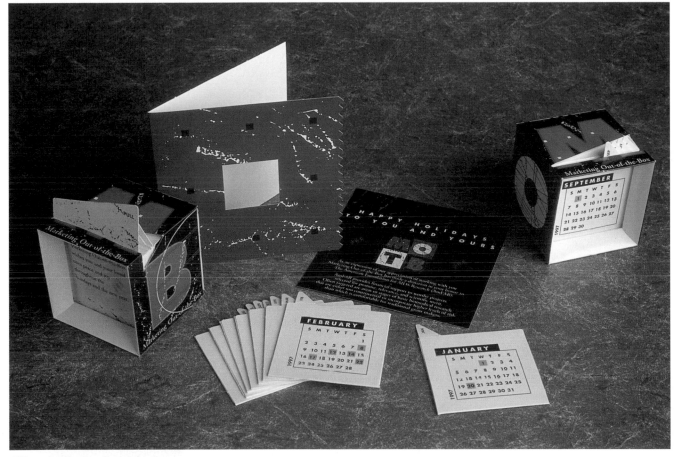

Client Marketing Out of the Box
Design Firm Jim Lange Design
Art Director Allison Hafti
Designer Jim Lange

The holiday promotion depicts various aspects of Marketing Out of
the Box's services to its clients through the use of original illustrations.
One of the sets is from 1997; the other was produced in 1998.

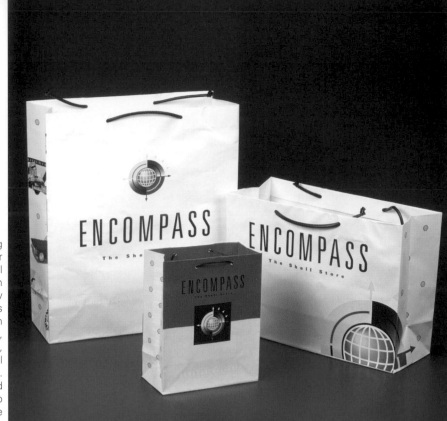

Part of the marketing campaign for the first-ever retail concept store for Shell Oil Company, the design employs the red-and-yellow color combination that is usually associated with the organization, and, to remove all doubt, the familiar shell symbol appears on the side panels. The high-gloss paper and PVC handles add to the slick appearance (no pun intended).

Client
Encompass, The Shell Store
Design Firm
ArtHouse Design
Art Directors
Marty Gregg and Craig Rouse
Manufacturer
Modern Arts Packaging

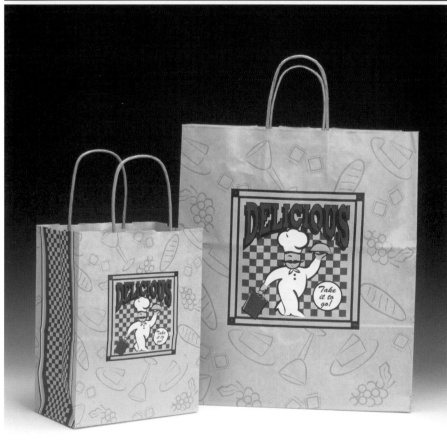

The promotional package serves up a playful attitude about self-congratulation.

Client
Bonita Pioneer
Art Director
Jim Parker
Distributor
Bonita Pioneer
Manufacturer
Bonita Pioneer Packaging

Client Supre
Design Firm Swieter Design U.S.
Art Director/Designer Mark Ford

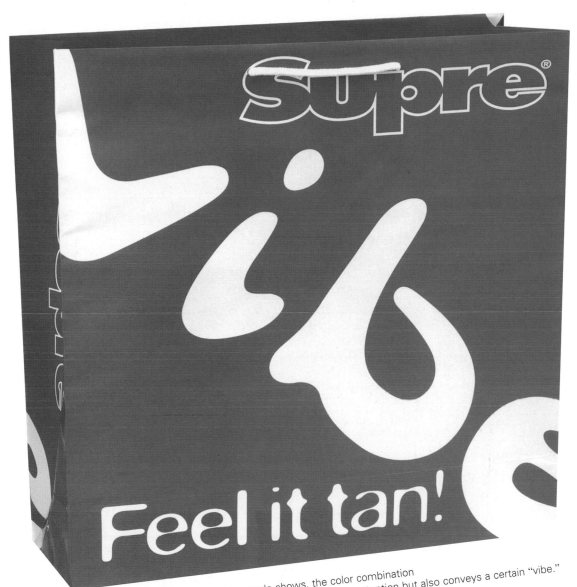

Designed to be distributed during trade shows, the color combination not only attracts attention but also conveys a certain "vibe."

Client Leo Pharmaceuticals
Design Firm Department 058
Art Director Vibeke Nodskov
Designer Asger Malmstrom
Manufacturer Carta Italia SRL, Villorba, Italy

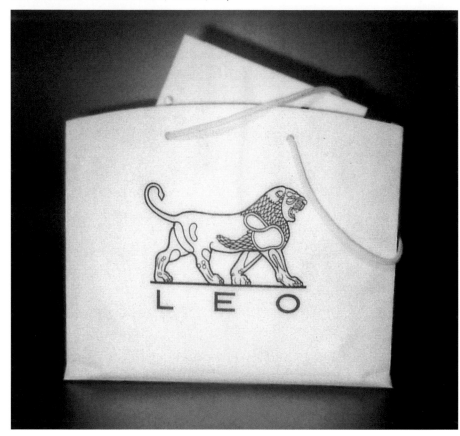

With its clean, uncluttered design, the bag is used at exhibitions to hold material from the company. The curve at the top, which is part of the corporate identity, served as a challenge to the manufacturer.

Client Bonita Pioneer
Designer Jim Parker
Distributor Bonita Pioneer
Manufacturer Bonita Pioneer Packaging

Client Dayton Hudson Corporation
Design Firm design guys
Art Director Steven Sikora
Designer Amy Kirkpatrick
Distributor Marshall Field's

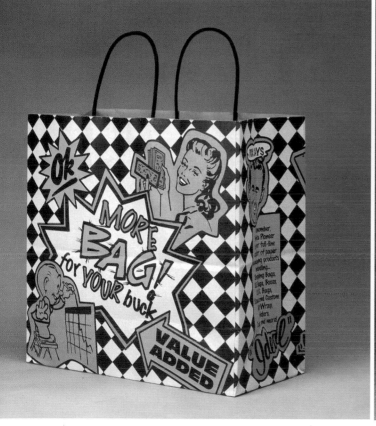

The promotional bag's graphics evoke the fun but garish product publicity from the 1950s.

The "Daisy Sale" bag, from a television and print campaign, brings to mind the bold design of mid-century product advertising. The yellow daisy placed among the bright greens screams outdoor freshness.

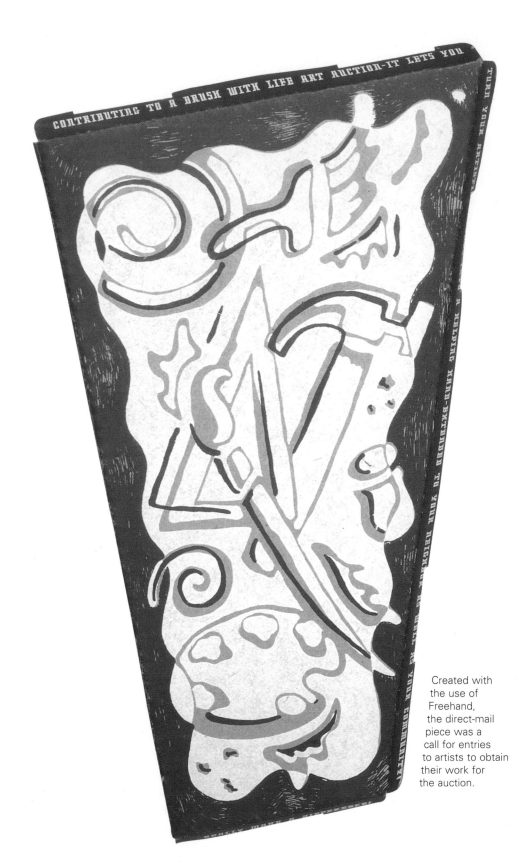

Created with
the use of
Freehand,
the direct-mail
piece was a
call for entries
to artists to obtain
their work for
the auction.

Client Mental Health Association of South Central Kansas
Design Firm Love Packaging Group
Art Directors/Designers/Illustrators Tracy Holdeman and Brian Miller
Manufacturer Love Box Company
Paper/Printing Corrugated "B" flute kraft
Silkscreening Rand Printing

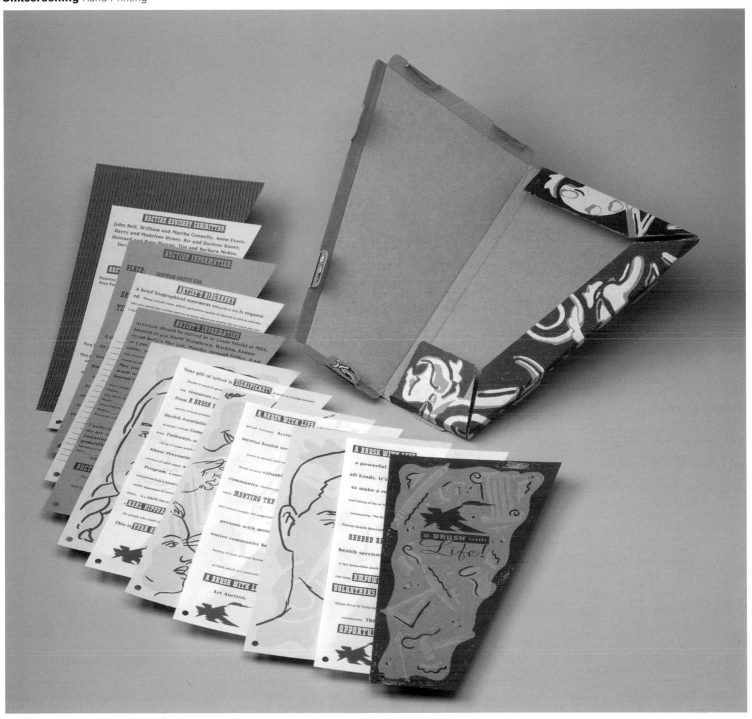

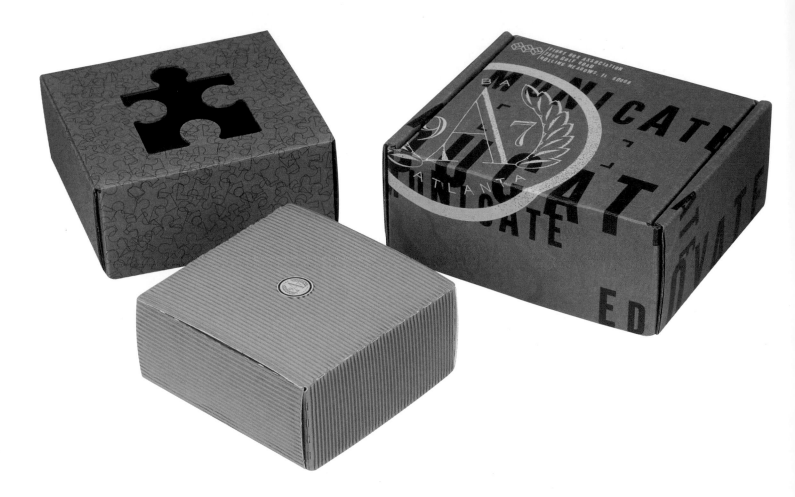

Client Love Box Company/Fibre Box Association
Design Firm Love Packaging Group
Art Director/Designer/Illustrator Chris West
Manufacturer Love Box Company
Paper/Printing Corrugated "B" flute kraft; single face "Outback" frazer paper
Silkscreening Rand Printing

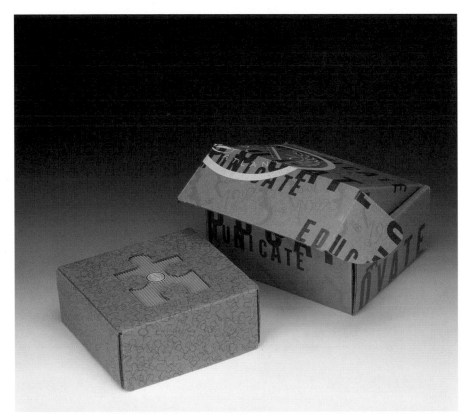

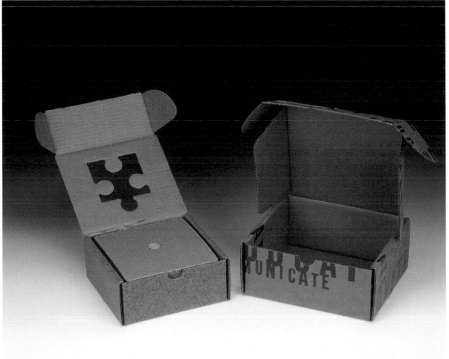

Invented in Adobe Photoshop 4.0 and Freehand 7.0.2, this unique piece employs the "puzzle piece" idea. The interior box holds a puzzle that, when assembled, gives the event details.

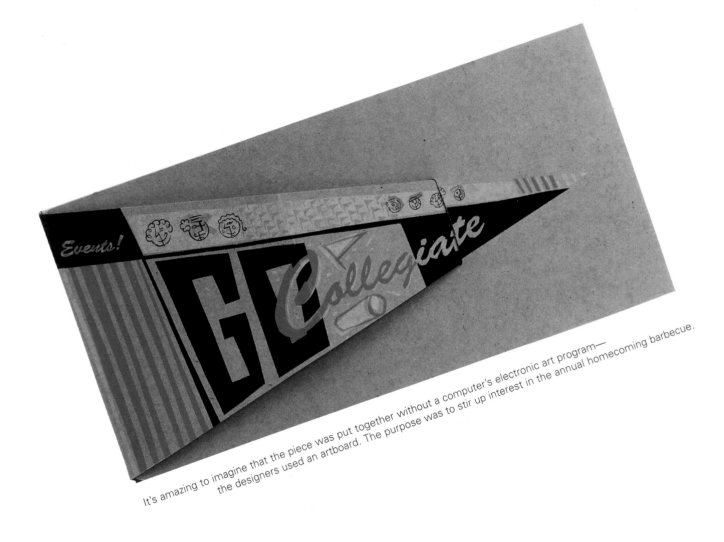

It's amazing to imagine that the piece was put together without a computer's electronic art program— the designers used an artboard. The purpose was to stir up interest in the annual homecoming barbecue.

Client Wichita Collegiate Schools
Design Firm Love Packaging Group
Art Directors/Designers/Illustrators Tracy Holdeman and Brian Miller
Manufacturer Love Box Company
Paper/Printing Corrugated "B" flute kraft
Silkscreening Rand Printing

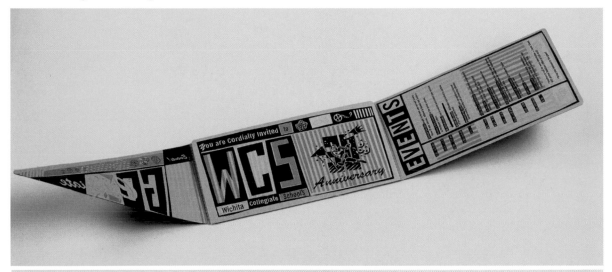

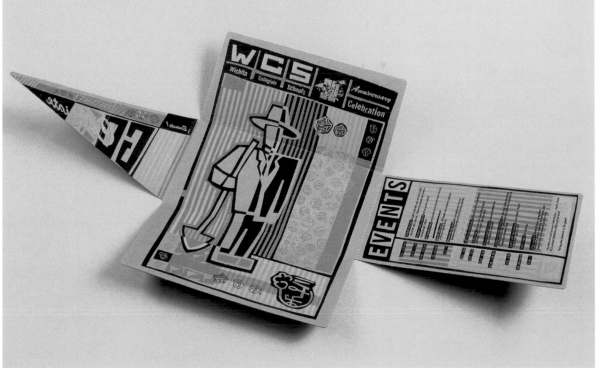

The two oddly shaped tags hearken back to 1950s and 1960s logo design.
The one-color printing kept production costs affordable.

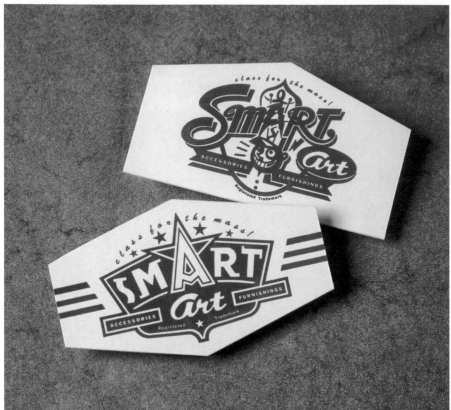

Client
Smart Art
Design Firm
Sayles Graphic Design
Art Director/Designer
John Sayles

Distributed during trade shows, the bag's basic design colorfully illustrates the client's specialties.

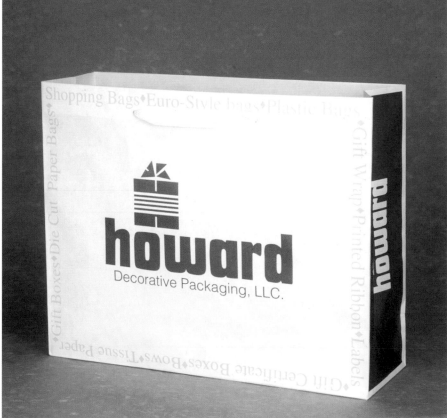

Client
Howard Decorative Packaging, LLC.
Distributor
Howard Decorative Packaging, LLC.
Manufacturer
Keenpac North America Limited

The T-shirt was created to increase traffic to the company web site, while the hangtag informs recipients of the current promotion.

Client Mires Design
Design Firm Mires Design
Art Director Jose A. Serrano
Designers Jose A. Serrano and Miguel Perez
Illustrator Tracy Sabin
Paper/Printing Ship Shape

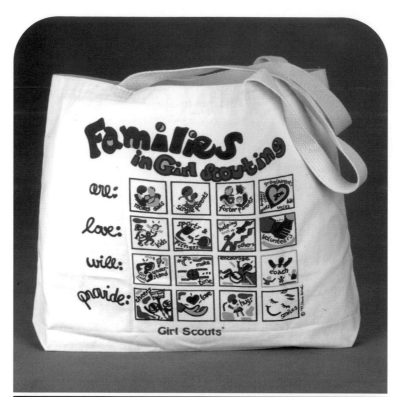

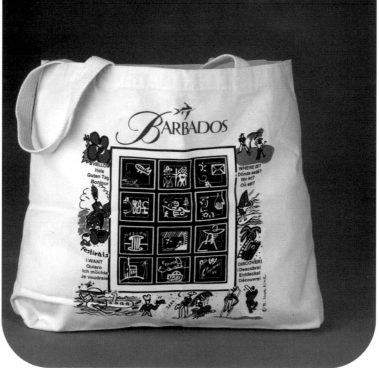

Clients Girls Scouts of America, Barbados Tourism Authority, and German-American Partnership Program
Design Firm Kind International/Uwe Kind
Designer Uwe Kind
Illustrator Peter Kind Legarth
Manufacturer Enviro-Tote Inc.

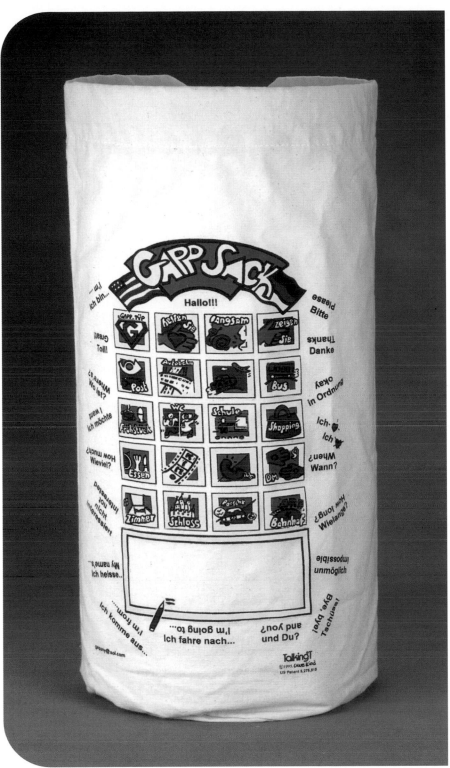

The limitless possibilities of language are the basis of the design for the Families in Girl Scouting Talking Tote, Barbados Talking Tote, and Gapp Sack. The first allows a person to make 64 positive phrases about Girl Scouting, the second one generates 120 statements in English, Spanish, German, and French, and more than 300 expressions in English or German appear on the third bag.

Client Alphabet Soup
Design Firm Sayles Graphic Design
Art Director/Designer/Illustrator John Sayles

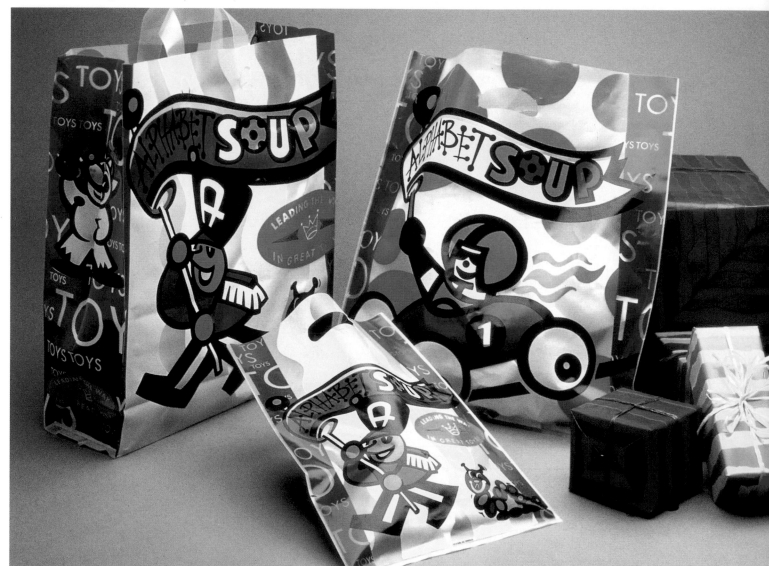

The vivid, elementary figures and lines in Alphabet Soup's corporate identity program recall the toys and friends of childhood.

Client Millennium Conference Center and Hotel
Design Firm NRI Digital
Designer Jeff Montaigne
Distributor The Metro Packaging Group, Inc.
Manufacturer St. Joseph Packaging, Inc.
Paper/Printing Solid bleach sulphate; one-color offset and varnish

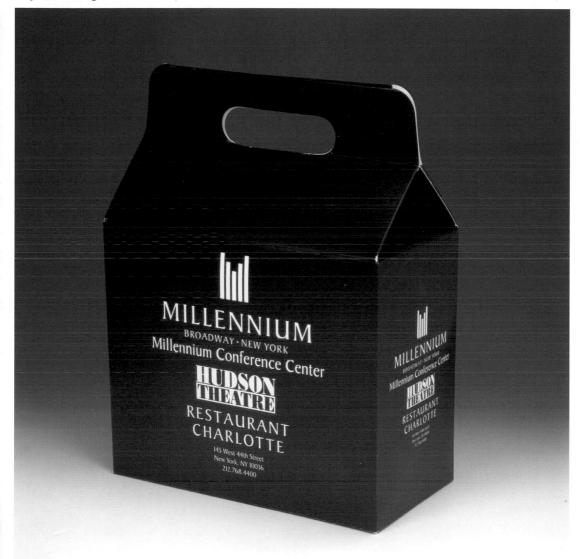

The challenge was to develop a handled box construction capable of holding meals for hotel corporate meetings.
Its easy assembly and lock-up closure were critical to the design and execution.

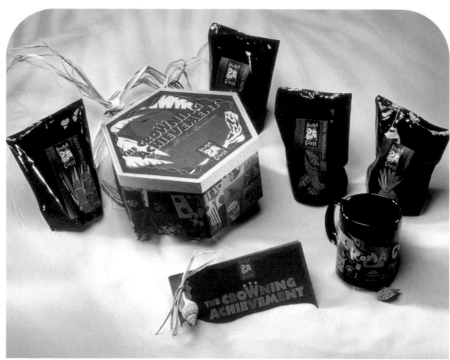

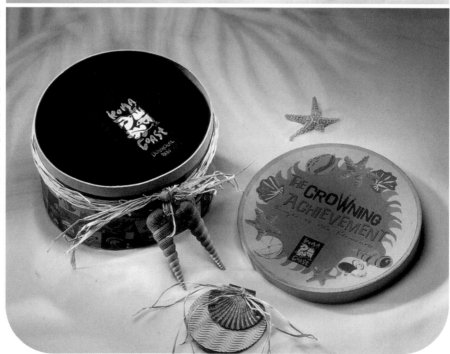

Client
Kona Coast Trip
promotion/Doskocil
Corporation
Design Firm
Gardner Design
Art Director
Bill Gardner
Designer
Brian Miller
Creative Director
Greg Menefee
of Menefee and Partners
Copywriter
Paul Hansen
of Menefee and Partners

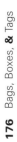

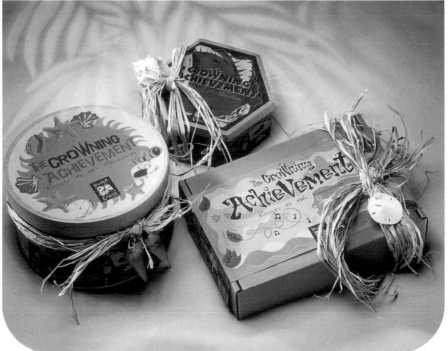

Intended as a sales incentive promotion for a trip to Kona, Hawaii, gifts include beach towels, personalized windbreakers, and gourmet Hawaiian foods. The shapes on the packages and their accoutrements convey a sense of whimsy and fun.

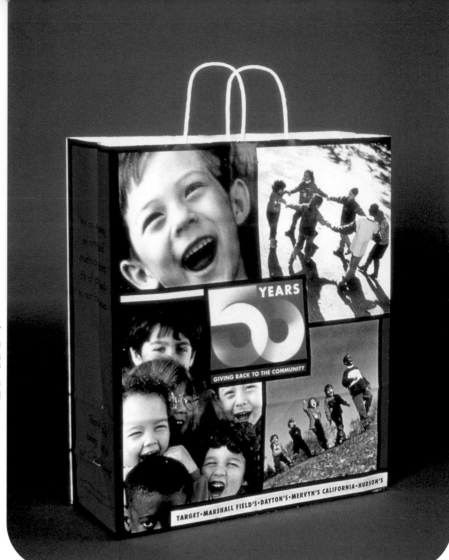

The "50 Years of Giving" bag was designed for use in all Dayton Hudson stores and commemorates half a century of the company's generosity toward the community.

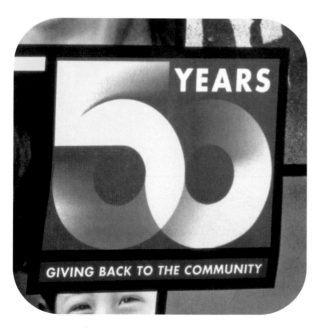

Client Dayton Hudson Corporation
Design Firm design guys
Art Director Steven Sikora
Designers Richard Boynton, Steven Sikora, and Amy Kirkpatrick
Distributor Marshall Field's

Presented to the department's volunteers, the chipboard supports a necktie
wrapped in kraft paper and secured with twine and a twig.

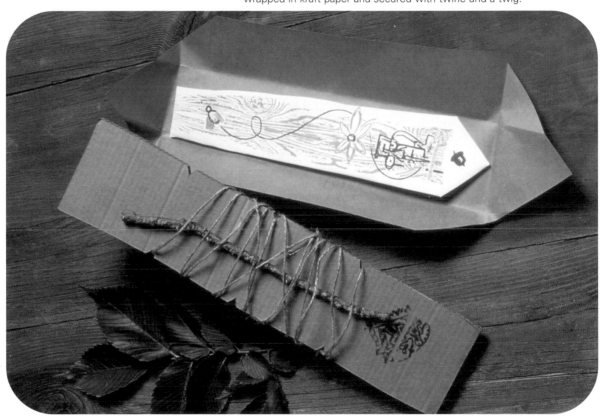

Client Des Moines Park & Recreation Department
Design Firm Sayles Graphic Design
Designer/Illustrator John Sayles
Paper/Printing Kraft, chipboard; screenprinting

Client
Applied Materials
Design Firm
Gee + Chung Design
Art Director
Earl Gee
Designers
Earl Gee, Fani Chung
Distributor
Applied Materials
Manufacturer
Commonwealth Packaging Company
Paper
1500 gsm white artpaper
Printing
Commonwealth Packaging Company

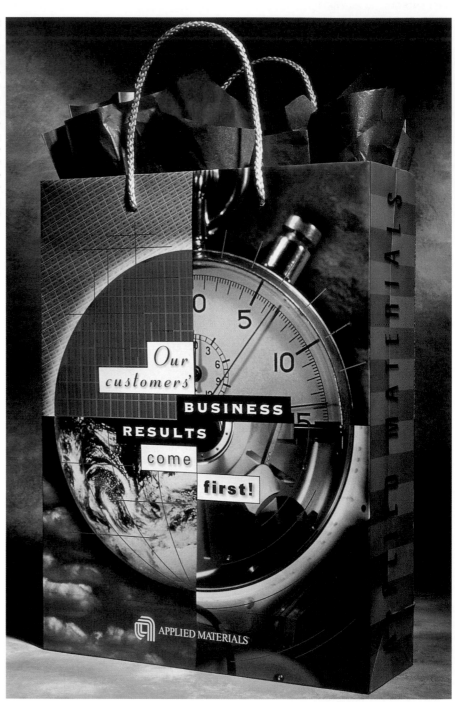

The corporate shopping bag sought to represent the company's products, processes, performance, and global infrastructure as parts of a whole.

Design Firm Planet Design Company
Principal John Besmer
Art Director Kevin Wade

Client Coleman Fuel Canister
Design Firm Love Packaging Group
Art Director Chris West
Designer Dustin Commer
Manufacturer Love Box Co.
Paper/Printing Love Packaging Group

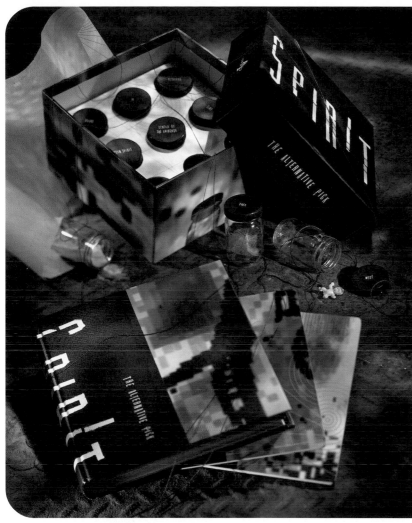

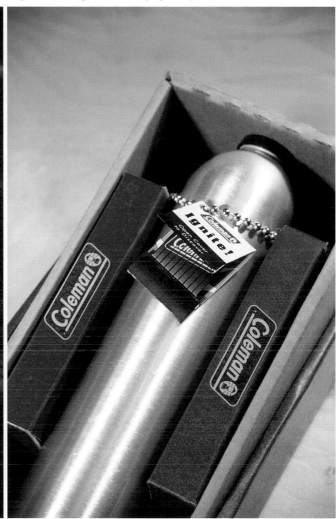

The Alternative Pick Book directs members of the recording industry to potential illustrators who produce art for album covers and promotional items.

Designed to introduce a new line of fuel products at a trade show, the packaging complements the sleek look of the product.

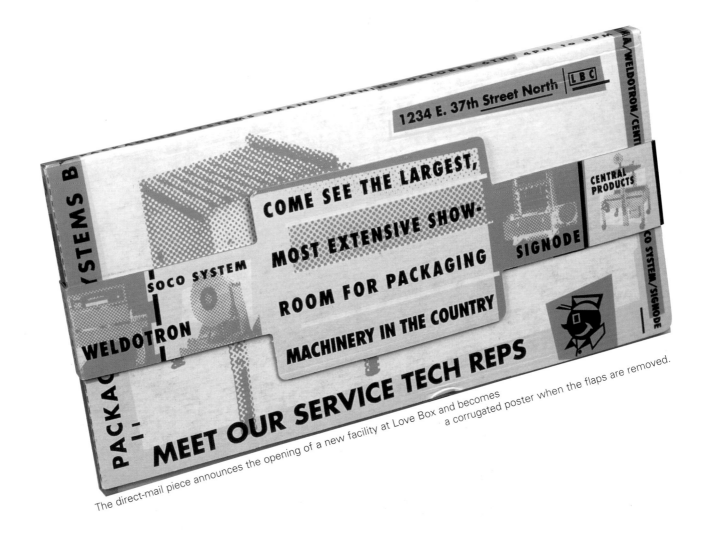

The direct-mail piece announces the opening of a new facility at Love Box and becomes a corrugated poster when the flaps are removed.

Client Love Box Company Packaging Systems
Design Firm Love Packaging Group
Art Director/Designer/Illustrator Brian Miller
Manufacturer Love Box Company
Paper/Printing Corrugated white "B" flute KLA
Silkscreening Rand Printing

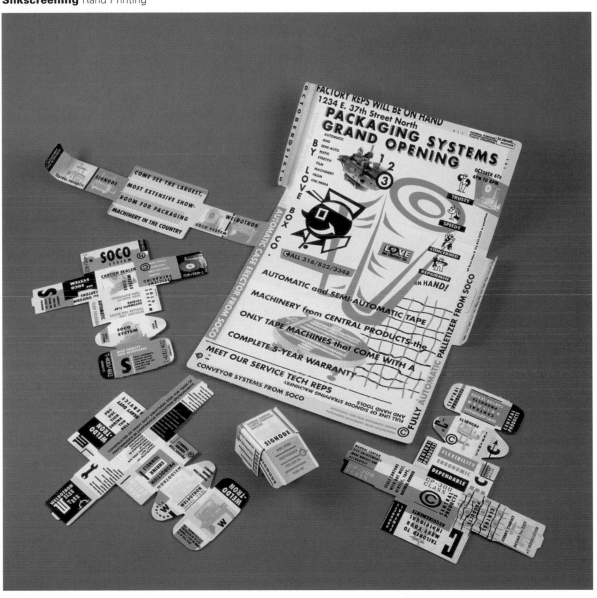

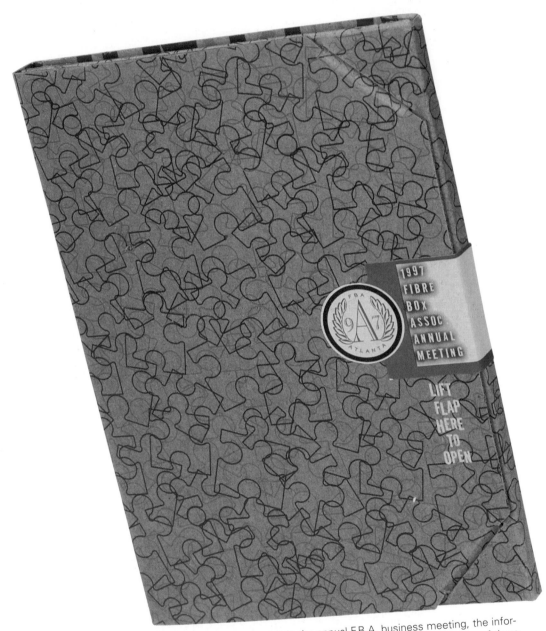

Meant to generate interest in the annual F.B.A. business meeting, the information packet, fashioned using Freehand 7.0.2, was one in a series of three to utilize the "puzzle piece" theme.

Client Love Box Company/Fibre Box Association
Design Firm Love Packaging Group
Art Director/Designer/Illustrator Chris West
Manufacturer Love Box Company
Paper/Printing Corrugated "B" flute kraft
Silkscreening Rand Printing

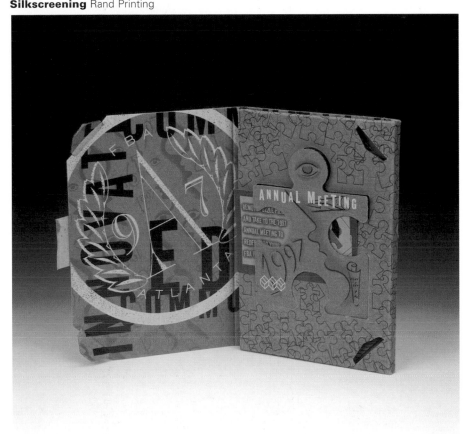

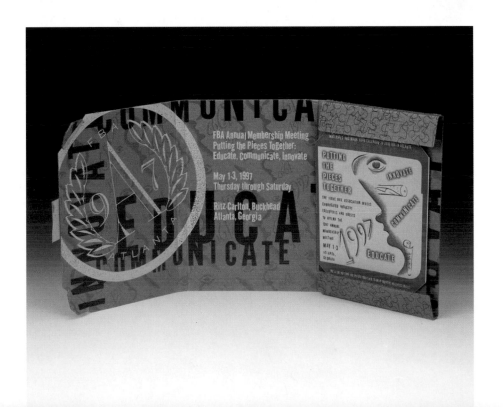

Directory

Addis Group
2515 Ninth Street
Berkeley, CA 94710

After Midnight
51 Melcher Street
Boston, MA 02210

Alexander Isley Inc.
4 Old Mill Road
Redding, CT 06896

Alphabets In-house
121 Varick Street, 6th Floor
New York, NY 10013

Antkoviak
112 W. 74th Street, 2nd Floor
New York, NY 10023

Aramis In-house
767 5th Avenue, Floor 38
New York, NY 10153

ArtHouse Design
20061 Northcliff Drive
Canyon Country, CA 91351

Atlas Paper Co.
P.O. Box 2186
220 Garfield Avenue
Woburn, MA 01801

Aurora Designs
1374 Dean Street
Niskayuna, NY 12309

Bagcraft Corporation of America
3900 W. 43rd Street
Chicago, IL 60632

Berni Design
660 Steamboat Road
Greenwich, CT 06830

Bonita Pioneer Design & Packaging
7333 S.W. Bonita Road
Portland, OR 97224

Borders, Perrin and Norrander
808 SW 3rd Avenue
Portland, OR 97204

Brad Thomas Design
P.O. Box 1011
Placerville, CA 95667

Bronz-Esposito Inc.
25 Bank Street
Stamford, CT 06901

Bullet Communications, Inc.
200 S. Midland Avenue
Joliet, IL 60436

Buttgereit & Heindenreich, Strategie–
Kommunikation–Design
Recklinghauserstrasse 2
45721 Halbern
Germany

Carré Noir
82, bd des Batignolles
75850 Paris Cedex 17
France

Clinique In-house
767 5th Avenue, Floor 38
New York, NY 10153

Commonwealth Packaging Company
7652 Trade Street, Suite B
San Diego, CA 92121

Communiqué Marketing
1520 West Main Street
Richmond, VA 23220

Conifer/Crent Company
4911 Central Avenue
Richmond, CA 94804

Crabtree & Evelyn
55-57 South Edwardes Square
London W8
England

Creative Division of Max Pack
109 N. Main Street
Elmira, NY 14901

Current Design
2930 Lyon Street, #1
San Francisco, CA 94123

Desgrippes Gobé & Associates
411 Lafayette Street
New York, NY 10003

Design Center
15119 Minnetonka Blvd.
Minnetonka, MN 55345

design guys
119 N. Fourth Street, #400
Minneapolis, MN 55401

Details In-house
Condé-Nast
350 Madison Avenue, 5th Floor
New York, NY 10017

Duro Bag Manufacturing Company
1 Duro Way
Walton, KY 41094

Elite Co. Ltd.
617 Bicycle Path
Port Jefferson Station, NY 11776

Elle In-house
1633 Broadway, 44th Floor
New York, NY 10019

Enviro-Tote Inc.
4 Cote Lane
Bedford, NH 03110

Estée Lauder In-house
767 5th Avenue, Floor 37
New York, NY 10153

Estudio Ray
2320 N. 58th Street
Scottsdale, AZ 85257

Fitch Inc./Hush Puppies Company
10350 Olentangy River Road
Worthington, OH 43085

Gardner Design
3204 East Douglas
Wichita, KS 67208

Gee + Chung Design
38 Bryant Street, Suite 100
San Francisco, CA 94105

Gina Amador Design
761 Sir Francis Drake Boulevard
San Anselmo, CA 94960

Grafik Communications, Ltd.
1199 N. Fairfax Street, #700
Alexandria, VA 22314

Greenebaum Brothers
1655 Union Avenue
Chicago Heights, IL 60411

Greteman Group
142 N. Mosley, 3rd Floor
Wichita, KS 67202

Hallmark Cards, Inc.
2501 McGee
Mail Drop 338
Kansas City, MO 64141

Handelok Bag Company
87 Commerce Drive
Telford, PA 18969

Harris Volsic Creative
262 South 200 West
Salt Lake City, UT 84101

Heins Creative, Inc.
1242 N. 28th Street, Suite 4A
Billings, MT 59101

hello studio
285 W. Broadway, #280
New York, NY 10013

Hillis Mackey & Company
1550 Utica Avenue, Suite 745
Minneapolis, MN 55416

Hornall Anderson Design Works, Inc.
1008 Western Avenue, Suite 600
Seattle, WA 98104

Independent Project Press
P.O. Box 1033
Sedona, AZ 86339

Interstate Packaging Corporation
P.O. 271 Colderham Road
Walden, NY 12586

Jarvis Press
9112 Viscount Row
Dallas, TX 75247

Jim Lange Design
203 N. Wabash Avenue
Chicago, IL 60601

Joel Katz Design, Inc.
1616 Walnut Street
Philadelphia, PA 19103

John Campagna Design
310 Lexington Avenue 150
New York, NY 10016

Keenpac North America Limited
1 Railroad Avenue
Goshen, NY 10924

Kind International/Uwe Kind
400 E. 59th Street
New York, NY 10022

Klearfold Inc.
300 Park Avenue, Floor 17
New York, NY 10022

Lambert Design
7007 Twin Hills Avenue, Suite 213
Dallas, TX 75231

Liberty Carton
870 Louisiana Avenue South
Minneapolis, MN 55426

Lipson-Alport-Glass & Associates
666 Dundee Road, Suite 103
Northbrook, IL 60062

Little & Company
1010 S. 7th Street
Minneapolis, MN 55415

Little, Brown and Company
1271 Avenue of the Americas, Floor 11
New York, NY 10020

Love Box Company &
Love Packaging Group
410 E. 37th Street North
Wichita, KS 67219

Mark Oliver, Inc.
One West Victoria
Santa Barbara, CA 93101

Matsumoto Incorporated
220 West 19th Street
New York, NY 10011

Mayer-Berkshire Corp.
25 Edison Road
Wayne, NJ 07470

Memo Productions, Inc.
611 Broadway, #811
New York, NY 10012

Metropolitan Museum of Art
1000 Fifth Avenue
New York, NY 10028

Mires Design
2345 Kettner Boulevard
San Diego, CA 92101

Modern Arts Packaging
38 W. 39th Street
New York, NY 10018

Morla Design
463 Bryant Street
San Francisco, CA 94107

Murrie Lienhart Rysner & Associates
58 W. Huron Street
Chicago, IL 60610

National Geographic
1145 17th Street NW
Washington, DC 20036

Neumeier Design Team
120 Hawthorne Avenue
Palo Alto, CA 94301

New Weave Corporation
337 Spartangreen Boulevard
Duncan, SC 29334

NRI Digital
44 W. 18th Street
New York, NY 10011

On the Edge Design
505 30th Street, #2110
Newport Beach, CA 92663

Package Land Co. Ltd.
201 Tezukayama Tower Plaza
1-3-2 Tezukayama-naka
Sumiyoshi-ku Osaka
Japan 558

Pacobond Inc.
9800 Glen Oaks Boulevard
Sun Valley, CA 91352

Parham Santana, Inc.
7 W. 18th Street
New York, NY 10011

Planet Design Company
605 Williamson Street
Madison, WI 53703

Port Miolla Associates
23 S. Main Street
Norwalk, CT 06854

Private Label
5481 Creek Road
Cincinnati, OH 45242

revoLUZion
Uhlandstrasse 4
78579 Neuhausen Ob Eck
Germany

RG Creations
939 Terminal Way
San Carlos, CA 94070

Robert Bailey, Inc.
0121 SW Bancroft Street
Portland, OR 97201

Rocha & Yamasaki
Rua de Joao Manuel
1078 Casa 6
Sao Paulo, SP 01411
Brazil

RTR Packaging & Design
27 W. 20th Street, #606
New York, NY 10011

Russell Leong Design
847 Emerson Street
Palo Alto, CA 94301

S. Posner Sons Inc.
950 Third Avenue
New York, NY 10021

Saatchi & Saatchi
Business Communications
255 Woodcliff Drive
Fairport, NY 14450

Sayles Graphic Design
308 Eighth Street
Des Moines, IA 50309

Sibley-Peteet Design
3232 McKinney, Suite 1200
Dallas, TX 75204

Siegel & Gale
300 S. Grand Avenue
Los Angeles, CA 90071

SJI Associates
1133 Broadway, Suite 635
New York, NY 10010

Smullen Design, Inc.
85 N. Raymond Avenue
Pasadena, CA 91103

Linda DeVito Soltis
137 Barn Hill Road
Woodbury, CT 06798

Sara Spinelli
459 Broome Street
New York, NY 10013

St. Joseph Packaging, Inc.
4515 Easton Road
St. Joseph, MO 64503

Hampel Stefanides
111 5th Avenue, Floor 11
New York, NY 10003

Swieter Design U.S.
3227 McKinney Avenue, Suite 201
Dallas, TX 75204

2M&G
14 Main Street
Tiburon, CA 94920

Tangram Strategic Design
Via Negroni 2
Novara 28100
Italy

TDC/The Design Company
165 Page Street
San Francisco, CA 94102

Tharp Did It
50 University Avenue, Suite 21
Los Gatos, CA 95030

Tom Dawson Graphic Designs
1000 W. Weatherford Street
Fort Worth, TX 76102

Allison Williams
333 South Seventh Street
Minneapolis, MN 55402

Williams and House
296 Country Club Road
Avon, CT 06001

Wolf Design II
333 N. Michigan Avenue
Chicago, IL 60601

Y.R.B.
David Abergel
478 Brody
New York, NY 10015

Zenith Paper Products Corp.
3450 W. Lehigh Avenue
Philadelphia, PA 19132

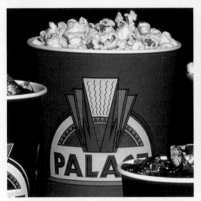

Index

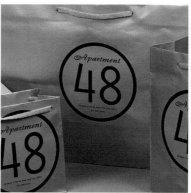

About the Author

Joyce Bautista is currently the design associate for *House & Garden* magazine. She scouts homes for potential publication, produces photo shoots, and researches and writes articles for the "Domestic Bliss" section as well as for feature stories. She has worked for *Condé Nast House & Garden* magazine and *PAPER* magazine. Originally from San Diego, California, Joyce now resides and works in New York City.